Artless

Artless

Art & Illustration by Simple Means

Marc Valli & Amandas Ong

An Elephant Book
Laurence King Publishing

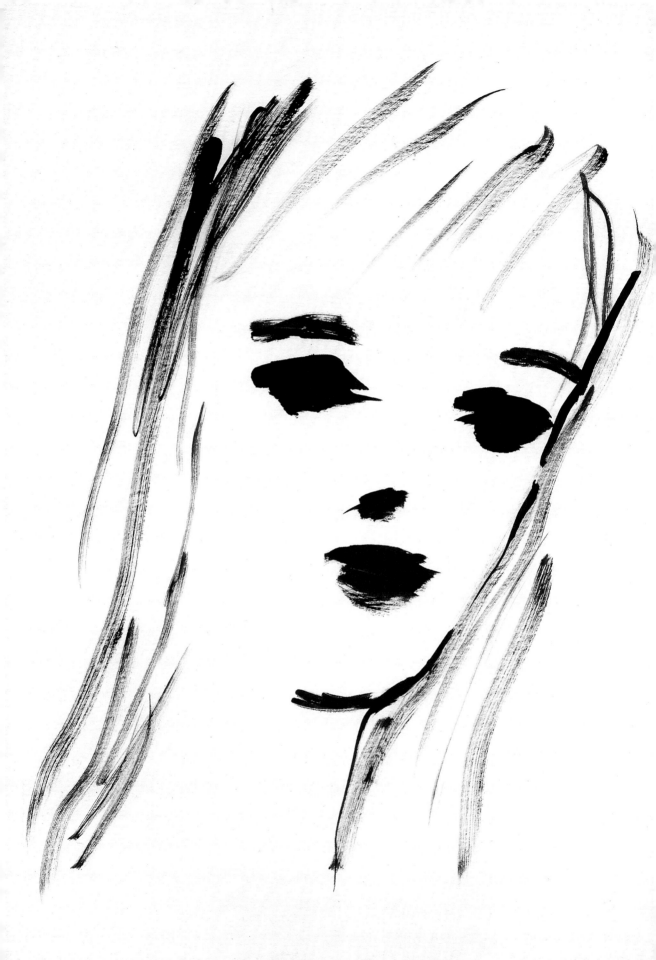

Contents

Zoe Taylor,
Untitled, 2013, ink
on paper, 27 x 21 cm
(10½ x 8 in),

Art History Year Zero

The battle against slickness

As visual landscapes around us grow ever slicker and more complex, with layers upon layers of images and interfaces merging into one another, it comes as no surprise that artists today are inclined to head in the opposite direction, looking for less sophisticated, more direct and spontaneous means of expressing themselves. In a world in which every available surface (and then every corner and square inch within that surface) has been carefully planned and designed to produce some kind of effect upon our retinas and our brains (and our wallets), a new generation of artists is growing ever more determined to embrace the idea of an art 'carte blanche'. Art School Year Zero: picking up a piece of paper and a few pens or pencils or crayons (sometimes going even further back into their own creative infancy and applying those to walls and furniture) to rediscover what it actually means to create an image and express something through visual means – rediscovering a sense of urgency, and intimacy, in their work. Today, for most of us, computers and image-making software have become synonymous with 'the office' and 'paying the rent', whereas actually to sit down and draw something, paper and pencils in hand, has come to stand for creative freedom, making art in a disinterested manner, within one's own intimate, imaginary sphere.

A pencil with a purpose

But then there are pretty down-to-earth reasons why, amid the global corporate businesses that make up the art world and the communications industries, one may want to start with something like a box of crayons. As a young artist you are hardly going to be able to compete with Damien Hirst, Antony Gormley, Anish Kapoor or Andreas Gursky in terms of putting together complex large-scale works. But you may stand a good chance with a pencil in hand – a very good chance against Hirst or Kapoor.

The New York-based French artist Damien Florébert Cuypers describes his love of high-quality crayons, which he discovered when his lifestyle started to become more nomadic: 'I no longer needed complicated materials or water, just crayons and papers, the simplest of things. I love carrying these little boxes of bright colours with me'. Cuypers will often draw characters at catwalk shows, and it is tempting to compare the directness and spontaneity of his work with that of early photographers such as Atget and Lartigue, and the freedom and compositional licence of portable-camera pioneers such as Beaton and Cartier-Bresson. I love the sense of sheer fun in the work of these photographers, and this is what I also find in the drawings in this book: the feeling that one is taking one's first steps in the world, and that this vast space is one's playground, filled with a sense of freshness and renewed surprise.

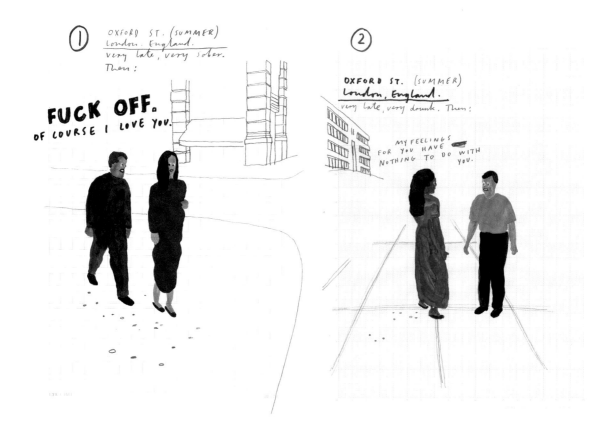

What is 'artless'?

It may have occurred to you that, for more than 15 years already, a number of successful artists have been hard at work creating explicitly (and deceivingly) unsophisticated works: the examples of Raymond Pettibon, Paul Davis, David Shrigley, Stefan Marx or the artist-poet-skateboarder Mark Gonzales all spring to mind. Deeply ingrained in the art world, and with museum retrospectives to their name, Pettibon and Shrigley have both stubbornly engaged in a self-conscious refusal of conventional aesthetic canons in favour of different strategies of art creation, disarming viewers with their supposed pictorial naivety, often with a large pinch of humour and social critique, and many layers of sarcasm. Needless to say, forging innocence, emulating spontaneity and faking monetary disinterest are the ultimate acts of artistic manipulation. Over the years, Pettibon, Davis, Shrigley, Marx and Gonzales have succeeded in creating their own parallel, and very personal, visual languages – and I have never ceased to marvel at the fact that, notwithstanding the disarming apparent simplicity of their techniques, the styles of these artists have proved to be, in the end, inimitable, despite endless attempts by less gifted practitioners. They are 'one-offs'. They may have opened doors and inspired the artists in this book, but I feel they don't quite belong in it: there is too much calculation – too many twists, second and third degrees – involved in what they do, and that is not quite what we are looking at here.

In the same way, while compiling this book, we have also decided not to pay too much attention to the idea of 'Post-Internet' art, though, again, there are striking parallels between this and the aesthetic choices of Post-Internet artists: a determination to break down compositional rules and grids, to throw away notions of good taste, visual and technical refinement, and so on. But unlike most Post-Internet artists, those featured in this book are wholeheartedly engaged in using very simple means to create aesthetically complex works. We have included some of the precursors to this type of work in this book: Philippe Weisbecker, Jean-Philippe Delhomme, Kim Hiorthøy (and we could possibly have included serious art-world players such as Marcel Dzama and Jockum Nordström). Indifferent to art and illustration fads, these visionary artists have been hard at work creating unique bodies of work, sometimes on simple schoolboy *cahiers* (as is the case with Weisbecker). And it is in order to celebrate their small (not meant as a derogatory word) and idiosyncratic (ditto) masterpieces, as well as those of their heirs, that we have put this book together.

Marc Valli

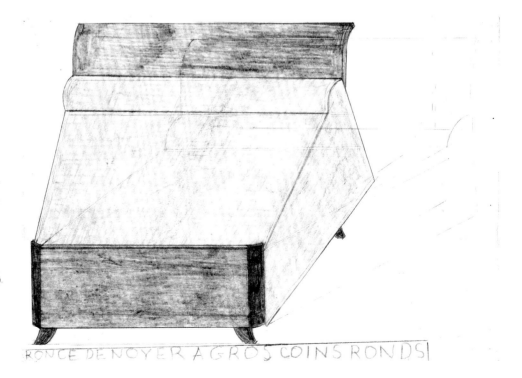

Opposite left:
Paul Davis,
Fuck off, of Course I Love You, 2003, pen, graphite and acrylic on paper, 30 x 21 cm (12 x 8 in).

Opposite right:
Paul Davis,
My Feelings For You, 2003, pen, graphite and acrylic on paper, 30 x 21 cm (12 x 8 in).

Right:
Philippe Weisbecker,
Ronce de Noyer a Gros Coins Ronds, 2005, graphite on paper, 16 x 25.5 cm (6 x 10 in).

Ianna Andréadis

Born: 1960, Athens
Lives: France

To create her illustrations, Ianna Andréadis goes back in time to look at the artistic vestiges of various civilizations, from the Aztecs to the ancient Greeks. She paints, photographs and makes books, allowing her experiences with these different media to flow into and inform one another.

Education I learned painting at the Angelikí Dágari workshop in Athens before going on to study painting and lithography at the École Nationale Supérieure des Beaux-Arts in Paris. My training in lithography helped me to pick and illustrate only the simplest and most essential parts of an idea.

Process I paint and draw mostly in ink, pastels and crayons. I love working with bamboo brushes because it produces a very elegant but spontaneous effect.

My creative process is inspired by my travel experiences and the great outdoors. I also turn to travel books and pictures to fill in the gaps where I think a particular 'sensation' is missing from my work. I need to work fast in order to capture the lived impressions, colour and energy of a place. I have also conducted a lot of iconographic research in the course of my practice.

Over the years, I have become very fond of the works of other artists that sit between figurative painting (Gilles Aillaud) and expressionism (Joan Mitchell, Per Kirkeby). I am fascinated by Chinese calligraphers and painters such as Xu Wei and Zhu Da. I feel their aesthetic espouses a sense of imperfect beauty through naturalism.

Left:
Terre, 1984,
acrylic on canvas,
80 x 80 cm
(31½ x 31½ in).

Opposite:
Galaxie, 1984,
acrylic on paper,
175 x 148 cm
(69 x 58 in).

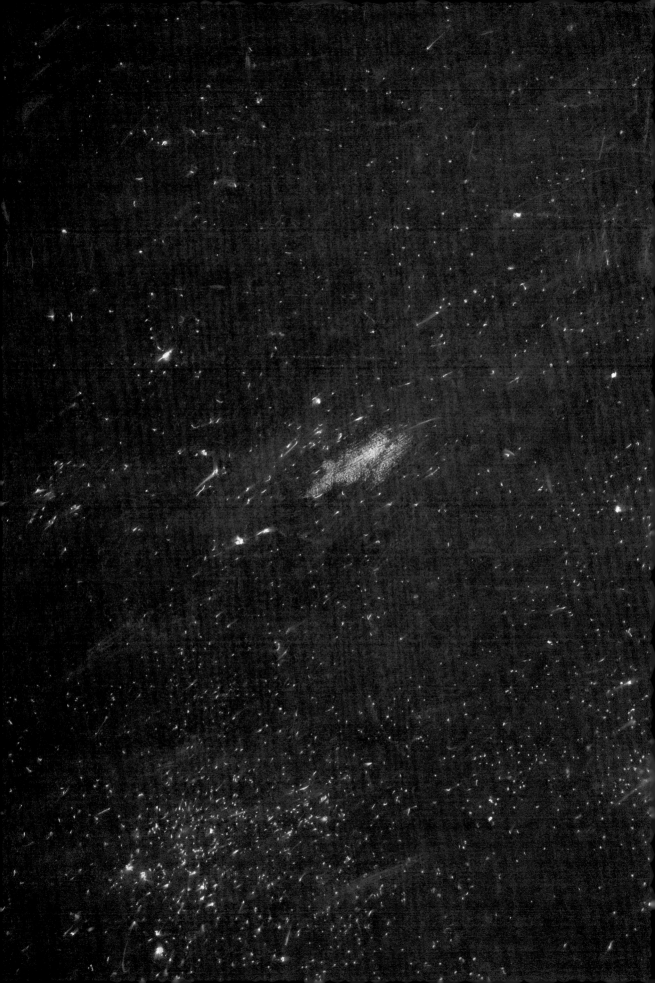

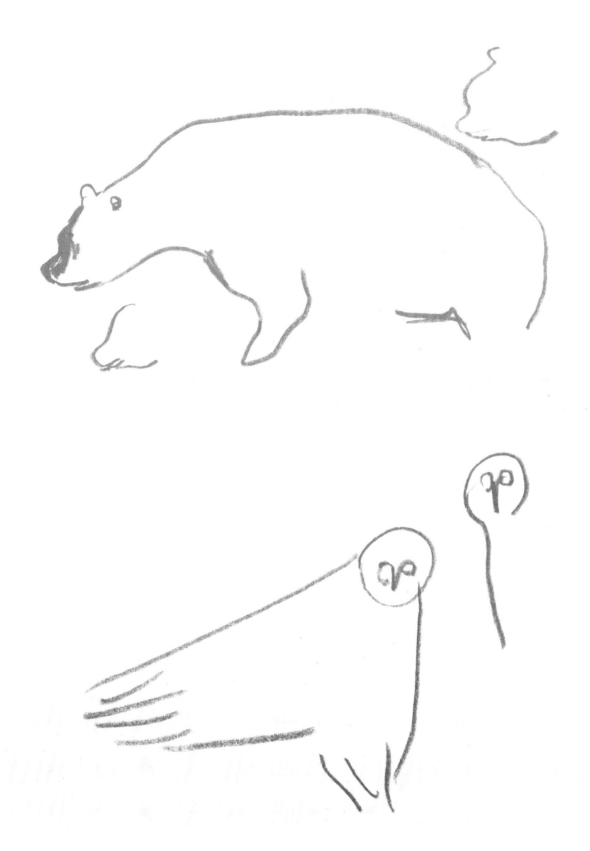

Top:
Ours, from *Un Bestiaire de
la Préhistoire*, first published by
Les Trois Ourses, 1988, lithograph,
15 x 21 cm (6 x 8 in).

Above:
Chouettes, from *Un Bestiaire de
la Préhistoire*, first published by
Les Trois Ourses, 1988, lithograph,
15 x 21 cm (6 x 8 in).

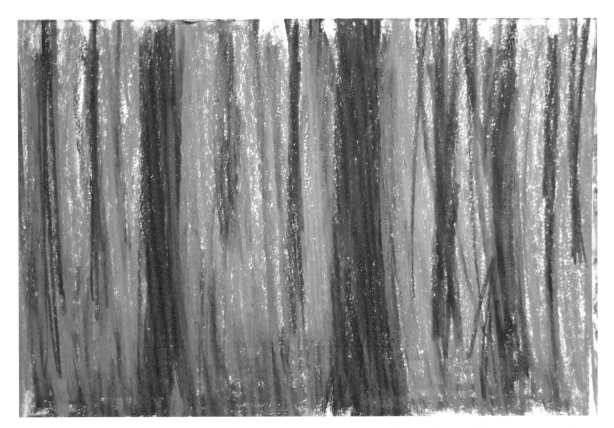

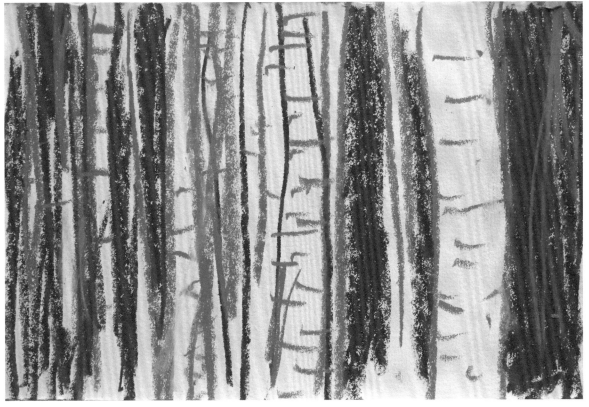

Top:
Forêt de Fontainebleau, hiver, 2012,
pastel, 20 x 30 cm (8 x 12 in).

Above:
Bouleaux, 2012, pastel, 20 x 30 cm
(8 x 12 in).

Edouard Baribeaud

Born: 1984, Versailles (France)
Lives: Berlin/Paris

The French-German artist Edouard Baribeaud describes his body of work as an archipelago, and envisions each of his paintings, drawings or films as an 'island'. Working in different media, Baribeaud strives to introduce a different narrative angle and vocabulary to every new project that he undertakes, citing Piero della Francesca, Pier Paolo Pasolini and Saul Steinberg as the three biggest influences on his practice.

Background Many of my drawings are informed by images from my childhood, evoking the illustrated adventure tales of the books I read. As a child, I wanted to become an illustrator of children's books. Today, my work tends to be more poetic and evocative than illustrative.

Process I graduated from the École Nationale Supérieure des Arts Décoratifs in Paris with a degree in illustration and printmaking. It was at the traditional engraving and silk-printing studios that I picked up my current method of conceiving and constructing an image.

I paint a bit like a printer, which means I apply the bright colours first and finish with the dark ones. The brightest element in the image is the white of the paper or canvas. So I construct a painting in layers, from light to dark. It is practically a philosophical process.

I tend to compare the creation of a series of paintings or drawings to the editing of a film. Some are static, but with certain pieces I can feel movement or hear sound, as if time is passing by in the image. I always have a problem getting rid of 'duds'. I store them in a special box, which is hidden away in a corner of my studio. It is my personal Bermuda Triangle.

I think that there are two phases and two spaces for inspiration and creation for an artist. First, there is the studio – a protected, withdrawn space. This is where ideas germinate. Then, creation outside the studio confronts the world beyond. It's a shifting process that responds to situations and events, like when you're filming or drawing outdoors.

I like to contrast the mundane and mythical, to take classical figures through modern landscapes and, in so doing, to blend real personal experiences with invented memories.

Left:
La fuite du sauvage, 2015, Indian ink and watercolour on paper, 29.5 x 46 cm (11½ x 18 in).

Opposite:
Offenbarung, from the 'Au Pavillon des Lauriers' series, 2012, ink on paper, 26 x 20 cm (10 x 8 in).

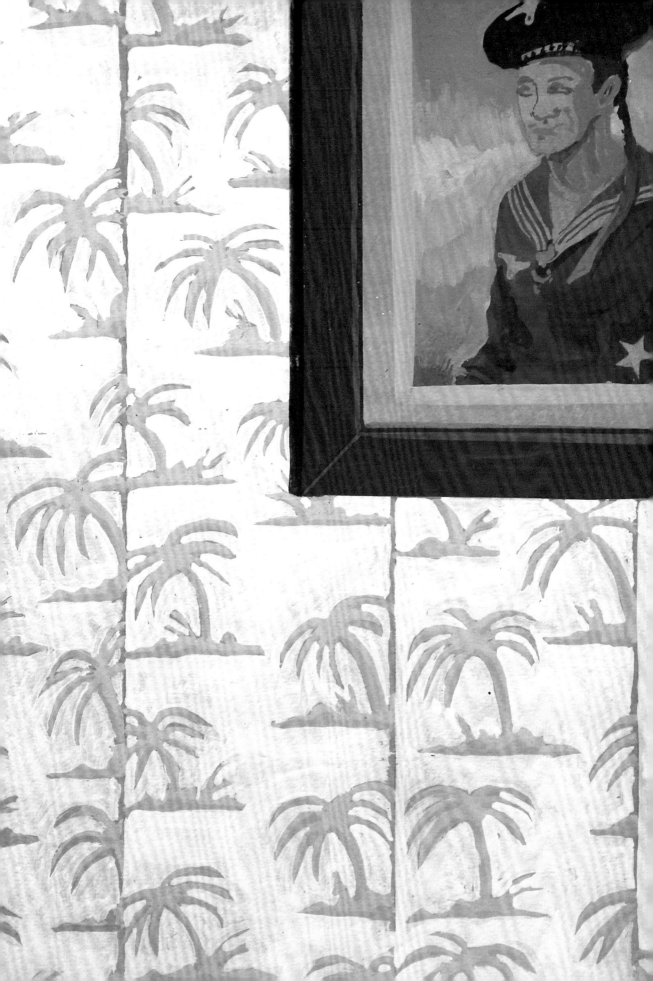

Tiziana Jill Beck

Born: 1982, Berlin
Lives: Berlin/Paris

German-born Tiziana Jill Beck says that her practice comes from fusing 'accidental elements together'. Intrigued by vivid colours ever since she began drawing, she challenges herself by exploring new mixed-media techniques that allow her to apply solid, bright and plain coloured settings on paper. After receiving a scholarship, she moved to Seoul, where she worked for a year. She explains that immersing herself in Korean culture and customs has altered the style of her current work.

Process On good days I can easily work for 16 hours non-stop. My approach is both associative and intuitive. I modify observations drawn from daily life, analogue or digital media, as well as literature and film. My process consists of combining and juxtaposing all these bits and pieces into an open narrative structure.

Drawing is an excellent medium to explore the world and make my position within it visible. I am especially interested in the contemporary phenomena of modern society, and people's relationships within a fast-changing environment. My work deals with strategy, success, cities, movement, failure, pressure, rivalry, irony, codes, habits, individuality, communication, conventions, fun, desire and nightmares.

My smartphone drawing app and coloured pencils are things I always have at hand. I feel very familiar with these tools and turn to them constantly for quick daily sketches. In the studio, I usually work very manually with a range of tools. By combining ink, coloured pencils, pigments and collage, I create drawings within a formally open atmosphere.

The use of crayon for plain surfaces on large-format paper is a ridiculous method. However, you can comprehend how every stroke wields the ability to express time and the physical activity behind it. I want to suggest a kind of vividness and suppleness in my drawings. My fascination with paper as a material derives from this idea, too.

Opposite left:
Ichlinge, from 'The Monkey Left
the Comfort Zone' series, 2014,
crayon and ink on paper,
120 x 85 cm (47 x 33 in).

Opposite right:
wood walk, from 'The Monkey Left
the Comfort Zone' series, 2014,
crayon and ink on paper,
150 x 104 cm (59 x 41 in).

Above:
Seoul Map, 2014, crayon and ink
on paper, 75 x 54 cm (30 x 21 in).

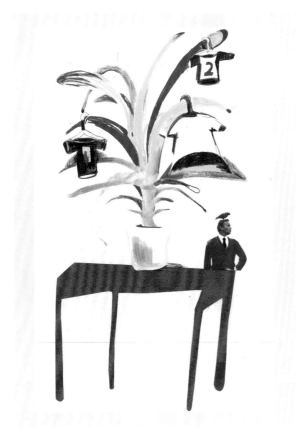

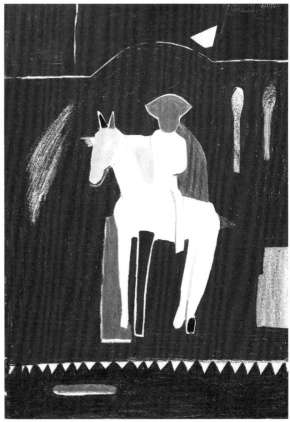

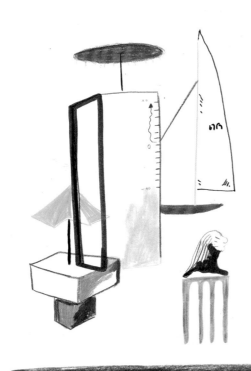

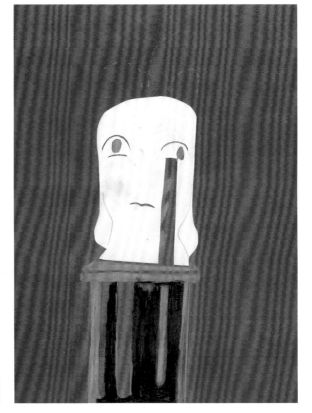

Top left:
Lucky Seventeen, 2014,
collage and colour crayon on
paper, 30 x 21 cm (12 x 8 in).

Above left:
LXXX California, 2014,
colour crayon on paper,
30 x 21 cm (12 x 8 in).

Top right:
Pioneer (élan et vitesse), 2014,
colour crayon on paper,
30 x 21cm (12 x 8 in).

Above right:
The Cure, 2014, collage
and colour on paper,
30 x 21cm (12 x 8 in).

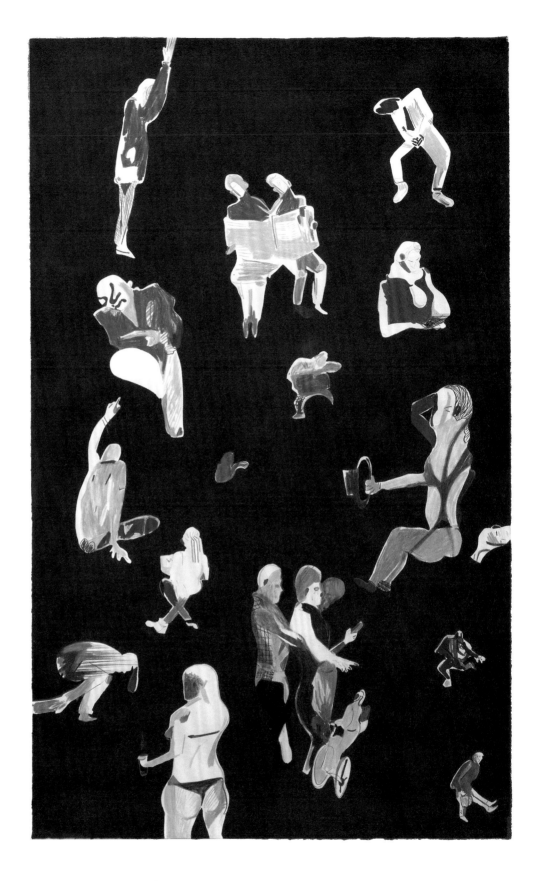

Commuter, from 'The Monkey Left
the Comfort Zone' series, 2014,
crayon and ink on paper,
85 x 53 cm (33 x 21 in).

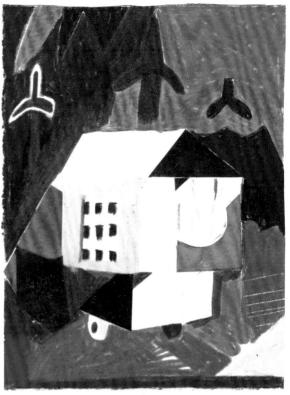

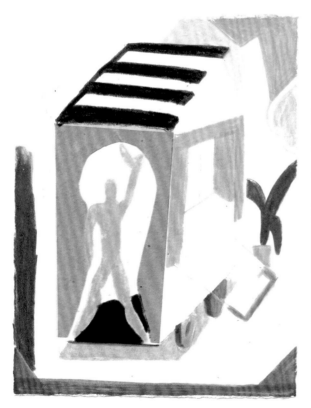

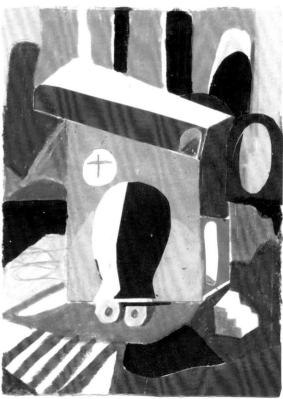

Opposite:
cell (meteorite), from 'The Monkey
Left the Comfort Zone' series,
2014, crayon and ink on paper,
120 x 85 cm (47 x 33 in).

Above:
From the series 'Tiny House
Movement', 2014, colour crayon
and collage on paper, each
15 x 11 cm (6 x 4 in).

Virginie Bergeret

Born: 1987, Pau (France)
Lives: Strasbourg

Virginie Bergeret has been drawing her entire life. When she was 15, she realized she wanted to turn her passion into her job. She studied at the École des Beaux-Arts in Angoulême, and went on to attend the École Supérieure des Arts Décoratifs in Strasbourg, graduating with a master's degree in illustration. After graduation, at last able to step away from art-as-academia, she began exploring and developing her own style.

Artlessness My drawings are not intended to disturb the observer. Rather, I'm looking for the kind of spontaneity that you can find in children's drawings. My experience of teaching art to young children has shown me that they are not concerned with what is beautiful and what is not. It is the gesture of making art that matters to them. This is exactly the kind of sentiment I am trying to rediscover through my work. I try to free myself as much as possible from existing aesthetic frameworks, and find a balance between composition and expression. I want to find pleasure in making images. I keep looking for raw, compelling simplicity.

Process I mix acrylic paints with ink so that the colours become brighter. Whenever I want to emphasize motion or movement in a drawing, I use oil pastels and coloured pencils, which make the images more dynamic. Bright colours are also good for giving depth and life to the characters in my work. The computer never features in my artistic process.

I need a few months to a year to work on most of my projects. For my 'Rosa Bird' series, for example, I created seven drawings in a day but was then stuck for a week. I had to return to pencil sketches before deciding on what I wanted for the final piece. I am perpetually going back and forth between painting, drawin and reconfiguring the composition of my works.

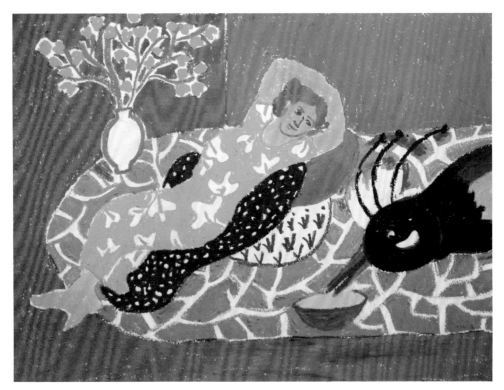

Left:
Illustration from the 'Rosa Bird' series, 2013, oil pastel on paper, 32 x 44 cm (12½ x 17 in).

Opposite:
From Bergeret's sketchbooks, 2013, felt-tip pens, each 30 x 42 cm (12 x 16½ in).

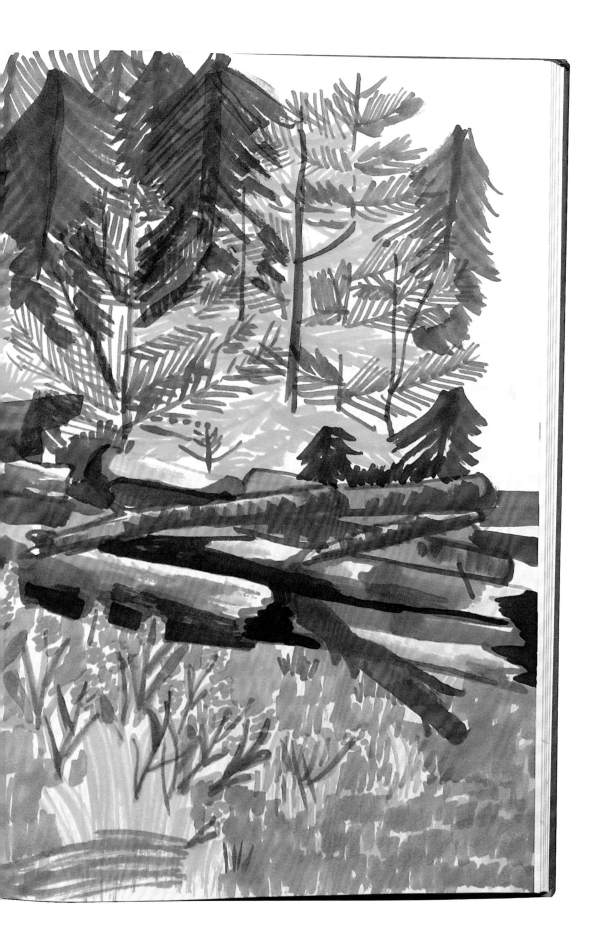

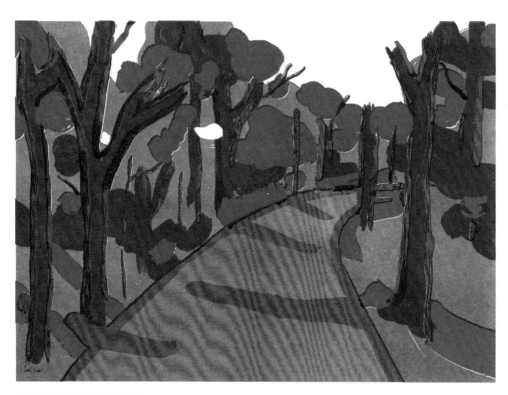

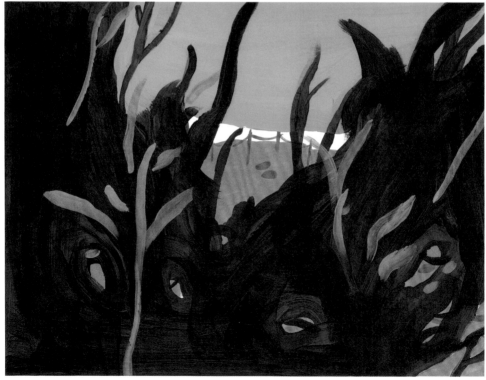

Below:
Double Noces, 2012, acrylic and ink
on paper, 60 x 90 cm (24 x 35½ in).

Bottom:
Double Noces, 2012, acrylic and ink
on paper, 60 x 90 cm (24 x 35½ in).

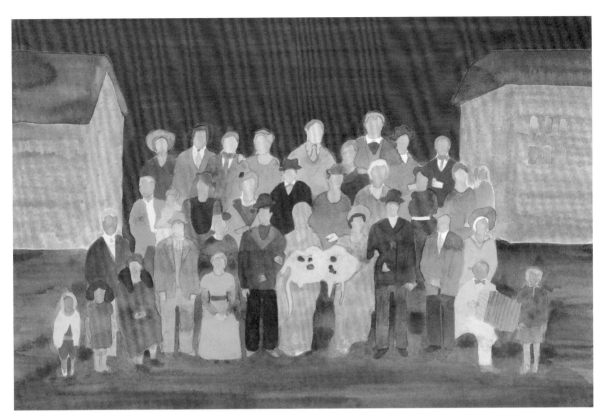

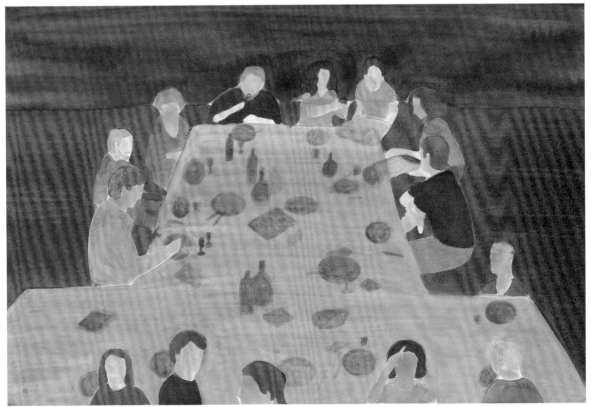

Serge Bloch

Born: 1956, Colmar, Alsace (France)
Lives: Paris/New York

The French illustrator Serge Bloch
has worked on more than 300
books, and his SamSam series has
reached more than 200 million
people worldwide. He studied under
the renowned French illustrator
Claude Lapointe at the École
Supérieure des Arts Décoratifs
in Strasbourg, and says that his
success is the result of a long,
slow process of development
towards a style that is 'simpler
and more efficient'.

Aesthetic philosophy I think we search all our lives to find the freedom that
we see in the drawings of children. They are focused and they don't care about
how other people judge them. There is a strength in children's drawings that
reaches the viewer directly. That's my motto: simpler is stronger.

Technique I love to draw. I love the line. And I love the collage: it's a marriage
between linear and graphic elements. I try to find my way into the contrast
between the delicacy of the line and the shape of these added elements.
Mixing them together creates an original story.

Of course, I work on my computer with Photoshop, this marvellous
toolbox! My relationship with my computer is ambivalent. Love and hate,
slavery and freedom.

I have no methods of 'quality control'. I try to be happy. I think that if I am
happy with my drawings, then other people looking at them will be happy too.

Below:
Perhaps not a word, 2015, acrylic
and ink on wood blocks,
60 x 20 x 20 cm (24 x 8 x 8 in).

Below:
My sweet heart, 2015, acrylic
and ink on wood blocks,
120 x 40 x 40 cm (47 x 16 x 16 in).

Opposite:
Balance, 2012, ink and collage
on Korean paper, 40 x 30 cm
(16 x 12 in).

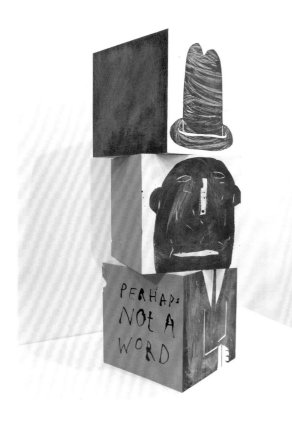

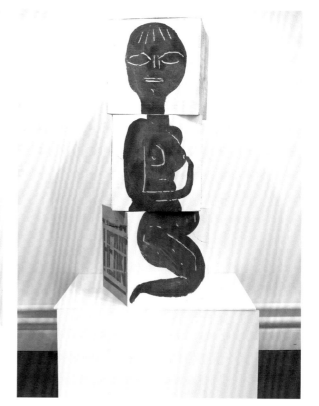

Good Student, 2013, ink on old book page, 25 x 20 cm (10 x 8 in).

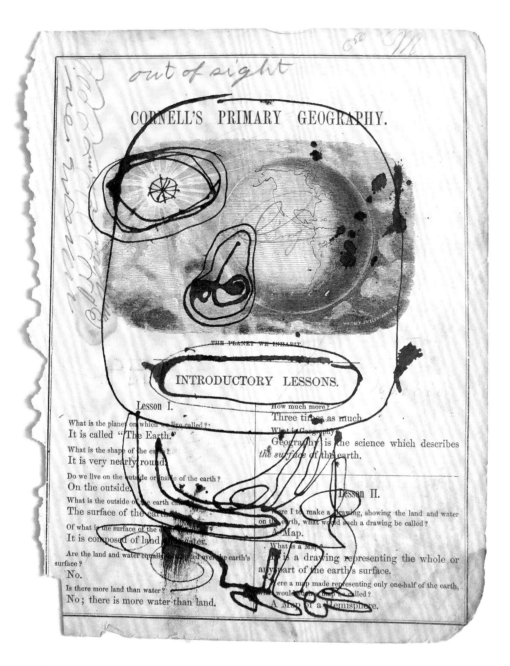

DROLE DE DAME

Block 2014

#01 COMMENT TORTURER SON BANQUIER

#01 'Comment torturer son banquier',
2015, digital, 80 x 60 cm (31½ x 23½ in).

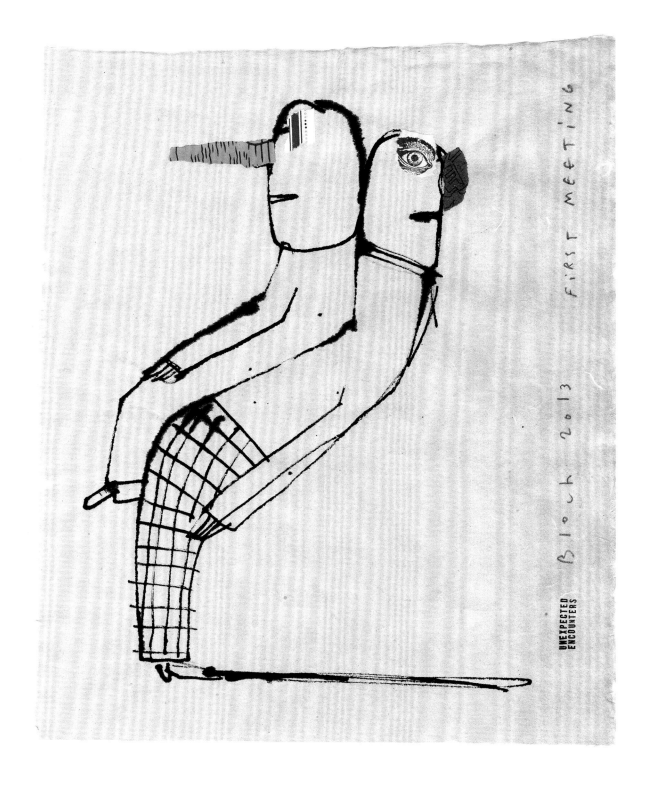

First Meeting, 2013,
ink and collage on Korean paper,
35 x 32 cm (14 x 12½ in).

Bath siren, 2014, acrylic on bathtub,
water and flowers,
approx. 2 m (6½ ft) long.

Laura Carlin

Born: 1980, Harpenden (UK)
Lives: London

Laura Carlin works as both an illustrator and ceramics artist, and won the Quentin Blake Award two years in a row while studying at the Royal College of Art. She describes her artistic journey as a tenuous one in which she struggled to 'get rid of years of thinking that a good drawing was one that looked like a photograph'.

Style I fell into studying illustration after learning on my foundation course that it would allow me to tell stories with pictures. Art school protected me for six years, and I met other people who couldn't spell. Like so many illustration students, I felt pressured by the need to find my own 'style'. It took me a while to realize that it's not about a style, but about working out what and how you want to communicate through your images.

My way of working developed from looking at a scene and slowly omitting what wasn't important. It's hardly rocket science, but I loved learning to edit my own images to put in the smallest amount of information possible.

I have always been interested in people's body language, and I try to convey that in my work. The way someone is standing can tell you how they're feeling. The interaction between two people, the way someone chooses something from a menu ...

Process Sometimes, on an average Wednesday afternoon, you'll come round and realize that two hours have gone by without you thinking rationally or looking at a blog. While in danger of sounding pretentious, this process gets harder and more priceless as you get older because of the lure of the internet.

I can normally tell if I've gone off into a world of my own and have willingly forgotten the brief! Sometimes I try and tell myself that a piece of work is OK when it's not – I tend to know when I'm being lazy (bad) and when I surprise myself (good).

I work on multiple pieces at once. I have perhaps three versions of the same page/image going at the same time. It means less pressure is applied than if there was just one, and I don't get bogged down in making pretty but false and laboured marks. I discard a lot of work. To produce a book of 30 to 40 pages, I will have around 200 artworks that haven't made it in.

I have a fondness for the colour rust. It's either because I'm middle class or because it's often used in the medieval drawings I look at.

Left:
Bedroom, from the 'Pick Me Up' exhibition, 2015, acrylic, watercolour and coloured pencil on paper, 20 x 30 cm (8 x 12 in).

Opposite:
Illustration for 'In Search of A Lost Africa', editorial illustration, *The New York Times*, 2008, acrylic, watercolour and coloured pencil on paper, 20 x 13 cm (8 x 5 in).

SIERRA LEONE

LIBERIA

MONROVIA

ATLANTIC OCEAN

SUGAR BEACH

ROBERTSFIELD AIRPORT

BUCHANAN

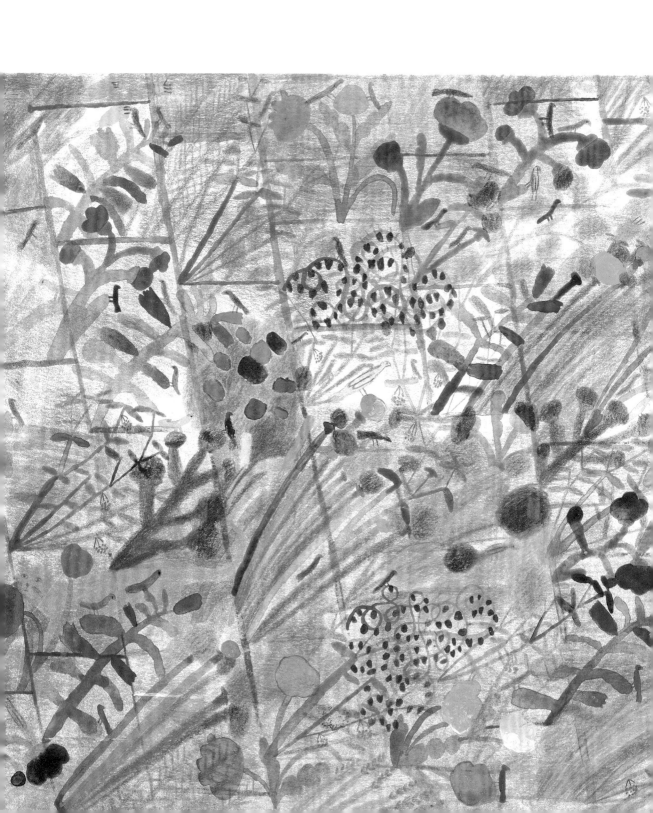

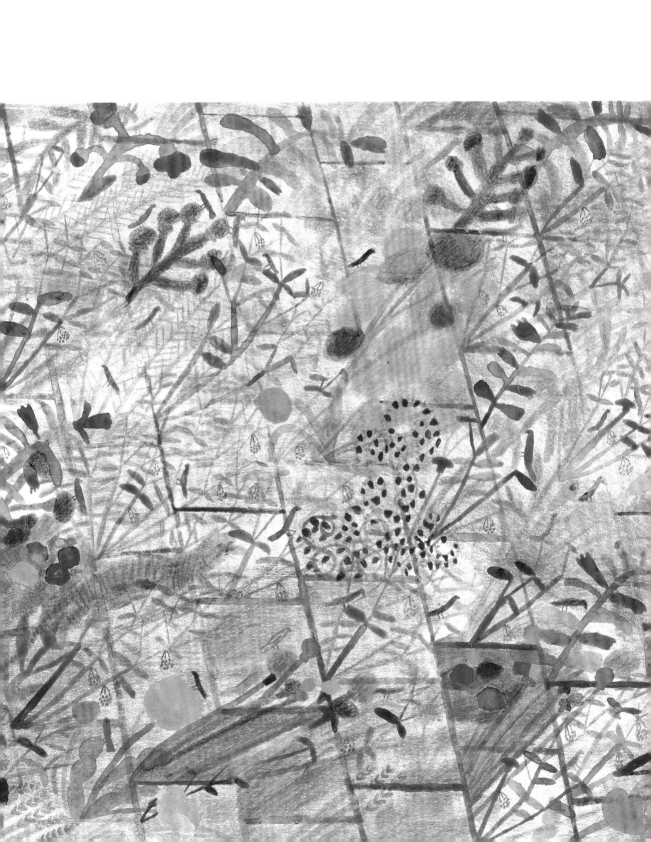

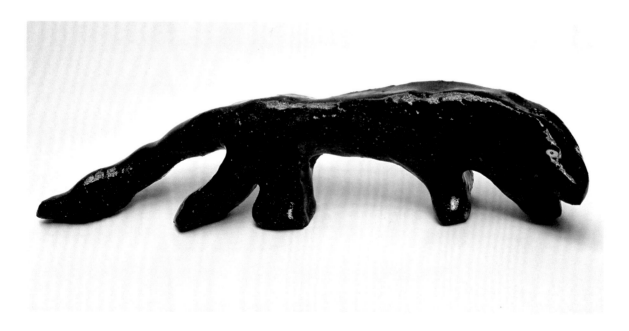

Édith Carron

Born: 1983, France
Lives: France/Germany

Édith Carron pithily summarizes the guileless appeal of her work as an extension of her being: 'My drawings reflect who I am: nervous, but with a strong and loud laugh.'

Background During my studies in Berlin, I started drawing daily in what I call my 'diary'. This urge to quickly transcribe an idea, or a scene I have observed or experienced, has led me to draw very spontaneously with coloured pencils.

From a certain point I said to myself that I was free to draw what and how I wanted. And with each new image I try to remind myself that I am allowed to draw as it suits me, and not forced to draw reality as it is. Maybe that's what kids do – they draw what they want without worrying about whether they are representing reality or not. But when you're an adult it takes some effort to represent the world in a personal way.

I don't often think about what I drew as a child. I think my awareness of colours and shapes is definitely something that was already present in my childhood, but my work today requires a more rigorous cognitive process. I am fascinated, though, by children's drawings. They have a spontaneity and a perfectly imperfect sense of design. I don't think too much about who my audience is when I draw, either, but I think there are many people like me who are more susceptible to spontaneous pictures than to polished images. We are surrounded by corporate images and photos that have been smoothly retouched – it's nice to see images that are more liberated.

I also feel very concerned about the countless stereotypes that are insidiously conveyed by the images around me. I think it is important to question the impact of the images that we create. I was once criticized for a poster in which all the girls were slim. Since then I've wanted to draw big women.

Materials I use coloured pencils almost exclusively. I prefer to redo the same drawing ten times rather than to correct it on a computer. As a result, the amount of paper and crayons I go through is incredible – but I still find this method more efficient than using Apple Z. There's a certain value and charm in keeping in errors.

A friend once told me that I use coloured pencils as if I'm painting. I press hard on the pencil to make intense colours. Sometimes I break pencils. I think that's what brings certain features in my work to life.

Colours I love using yellow and dirty green in my work. Dirty colours are able to bring out the best in any other colours, and make an image brighter. I try and avoid using black. I prefer to use midnight blue, which works better with other colours. There is a sky blue that is currently my favourite colour.

Le chocolat des français, 2015, pencil on paper and computer, 10 x 13 cm (4 x 5 in).

bk height, 2014, coloured pencil
on paper, 30 x 23 cm (12 x 9 in).

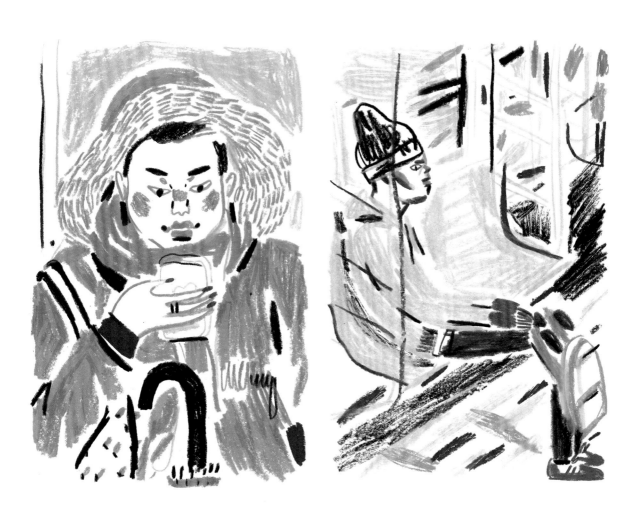

I saw you drawing in the L train,
2014, coloured pencil on paper,
22 x 14 cm (9 x 6 in).

I saw you drawing in the L train,
2014, coloured pencil on paper,
22 x 14 cm (9 x 6 in).

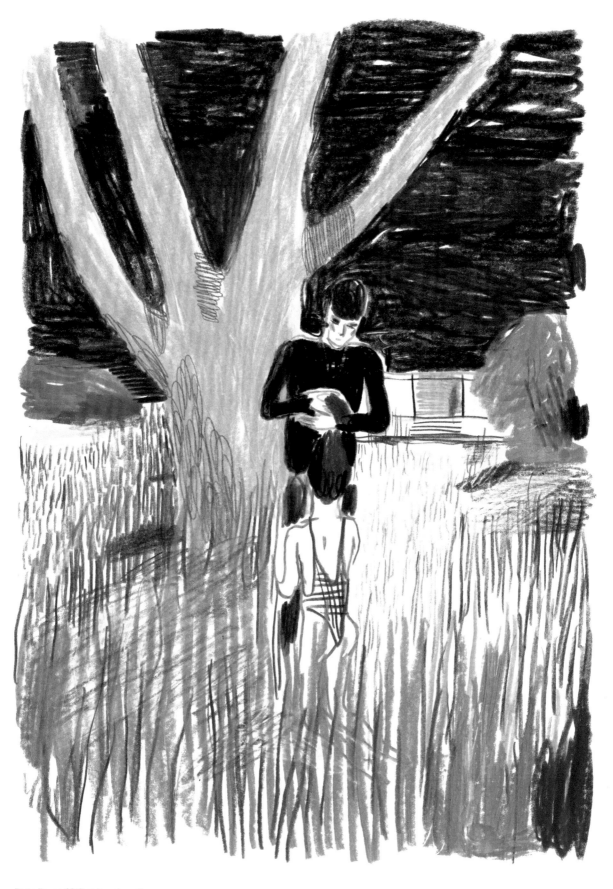

Fente Douce, 2013, coloured pencil
on paper, 30 x 21 cm (12 x 8 in).

Opposite:
wild Wald, 2012, coloured pencil on paper, 14 x 14 cm (6 x 6 in) repeated pattern.

Below left:
Graphic recording: culs pur toi, 2013, pencil on paper, 30 x 21 cm (12 x 8 in).

Below right:
Baiser, 2014, coloured pencil on paper, 30 x 23 cm (12 x 9 in).

Sofia Clausse

Born: 1989, Buenos Aires
Lives: Lisbon

**Born in Argentina, Sofia Clausse
has lived in Miami, Lisbon, London,
New York, Providence and Portland.
She graduated from the Rhode
Island School of Design with a
degree in graphic design in 2014,
and has since worked for Wolff Olins
and Nike.**

Background I developed an interest in graphic design at an early age,
teaching myself to make websites for my teddy bears and Pokémon fan clubs,
and later in life I started to appreciate artists and designers from looking at
art books and magazines. Having lived in so many different places has added
a lot to my practice. In Argentina you see a lot of hand-painted typography on
shop signs or in the streets, and I think this has given me an appreciation of
imperfect marks. In Portugal you find very decorative type on ceramic tiles,
with a lot of patterns and colours.

Child's play I like to alter tools or use them in ways that they're not supposed
to be used, thus discovering something unexpected. I like making my own
tools or systems for designing, almost like creating rules for a game, or
making new machines for mark-making. If I'm having fun or laughing while I'm
designing, I know I'm on the right path.

Materials I've used everything from balloons to fabric to paint to paper to
pixels. The one constant seems to be typography. A lot of the time my work is
about exploring letterforms using different materials and tools, so I try to play
with as many things as I can! Eventually it all ends up on the computer, to be
documented and refined. I'm aware that, regardless of which materials I use,
most of the people who see my work will experience it digitally, so I try to use
this to my advantage, documenting the work in interesting ways.

Process I like to embrace imperfection. I like things that are 'wrong', things
that are a bit messed up, things that don't look the way they're supposed to.
Those are the things that excite me and catch my attention. Imperfection is
human, and that's something I can connect with.

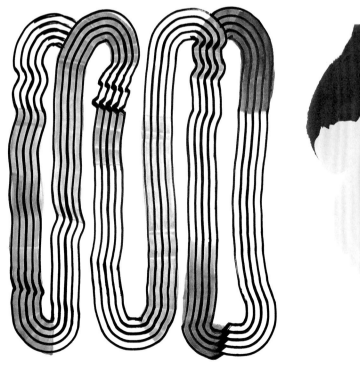

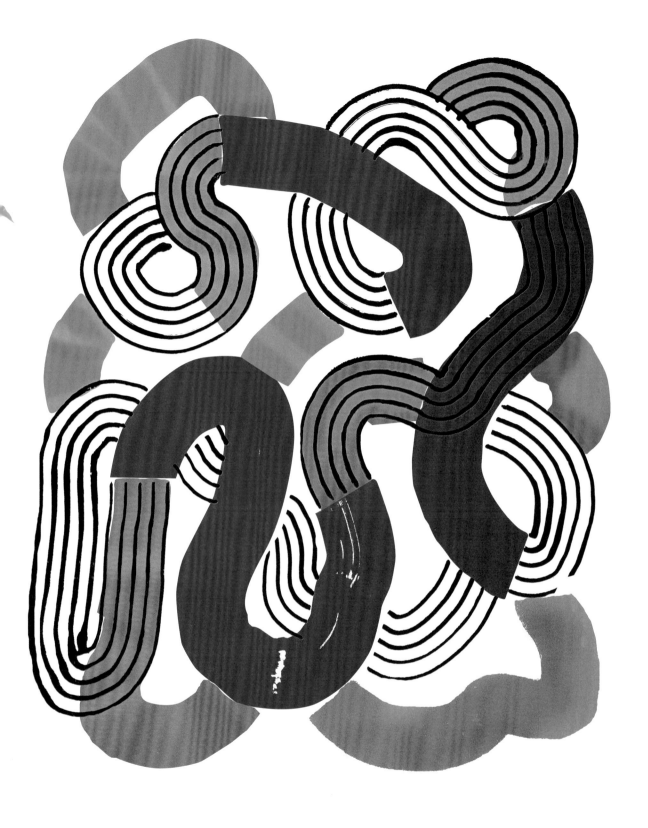

Opposite left:
Racetracks snakes and ladders #1,
2015, acrylic markers on Bristol
paper, 60 x 48 cm (24 x 19 in).

Opposite right:
Goinggongoing Squeegee,
2013, silk screen,
42 x 30cm (16½ x 12 in).

Above:
Racetracks snakes and ladders #2,
2015, acrylic markers on Bristol
paper, 60 x 48 cm (24 x 19 in).

Overleaf:
Sketchbook, 2014, mixed media,
21 x 30 cm (8 x 12 in).

Damien Florébert Cuypers

Born: 1983 Ambilly, Haute-Savoie (France)
Lives: New York

'I'm a total child. Only now I make a living from it', says the New York-based French illustrator Damien Florébert Cuypers, arguing that he doesn't know much about art: **'In a way, that's a good thing – it preserves a little magic. I particularly love my artist friends who introduce me to new concepts and outlooks. They are like punks, seeing the world for what it is: brutal and beautiful.'**

Background I love colour and I love a hand-drawn line. I tried coloured pencils and pastels but they were either too faded or too blunt, and not exactly what I needed. It was a blessing that one day I discovered high-quality crayons; they are the perfect in-between for me. Coincidentally, that happened as my lifestyle became more nomadic. I no longer needed complicated materials or water, just crayons and papers, the simplest of things. I love carrying these little boxes of bright colours with me, and I love that this technique also channels the child in me.

My first portrait with crayons was done during a drunken evening with friends at the Rosa Bonheur tavern in Paris, where I tried to draw everyone as fast as I could. It was too much fun for me not to do anything with it.

Colour Colour has always been very important to me. I never quite understood why people would try to camouflage themselves under layers of grey, black and beige. When I was 8 my mum let me choose some blue suede high-tops from a discount shoe shop for *la rentrée* ('back to school'). Of course I was mocked a bit for them, but I knew they were awesome so I didn't mind much.

I love fashion – it is like 'character design'. Big, small, flowing, tight, patterned, colour blocks ... these are all tools for people to reinvent themselves. Portraiture itself was never a key interest for me. And what I love about sketching people with crayons is the instantaneity of it, and how silly it can be. Ultimately the people I draw are just patches of colours put together.

Process My creative process begins with the Now, the problems I might have to resolve, and lots of random references that collide in my head: mountains, memories of picking blueberries in the forest, playing Final Fantasy VII, skiing at sunset, fighting with my sisters, laughing with them, feeling snowflakes on my cheeks or waves between my toes Oh, and blue suede high-tops.

Faux-naive versus really naive There are two main things to know about that have led me to work in the way I do:
1. When I was a kid I was always hearing about *la crise* ('economic crisis') and *le chômage* ('unemployment') – terrible things that seemed to affect even people with good office jobs. So I decided that I would not waste my life in a dumb office only to get fired and end up on the streets.
2. As a teenager I would look at fashion spreads in magazines, where you would have a close-up of the model with details of what they were wearing written on the side so you would know what brand of socks they were wearing, and how much they cost, even though you couldn't see them.

So now I can scribble on a piece of paper and say it's Kate Moss wearing Prada; people are so impressed, yet it's actually just a little black-and-pink scribble on a piece of paper.

Left:
Drawings made during a Hermès in-house residency ahead of the Men's show, 2015, Neocolor II crayons on 90g paper, various sizes.

Opposite:
Miriam Odemba exiting the Chanel show, 2015, Neocolor II crayons on 90g paper, 21 x 14 cm (8 x 6 in).

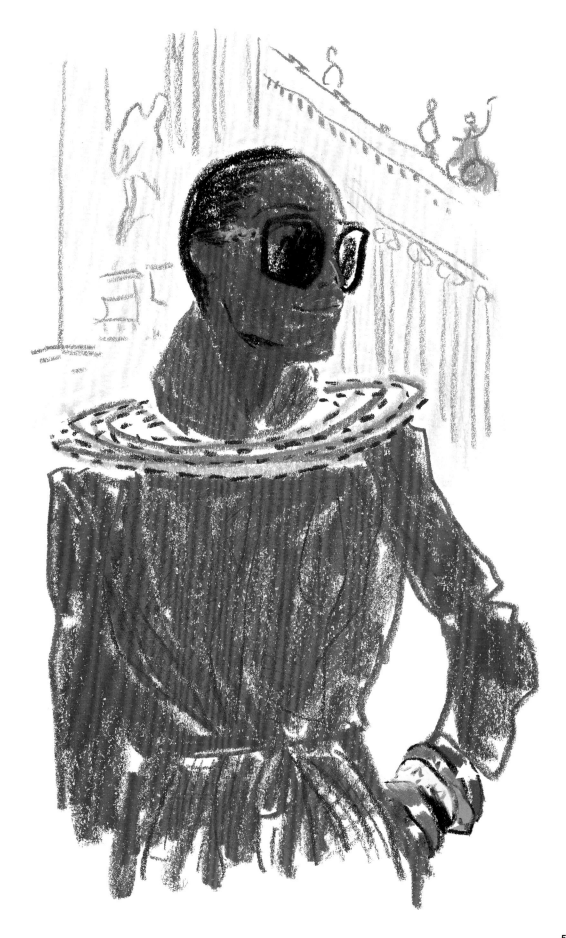

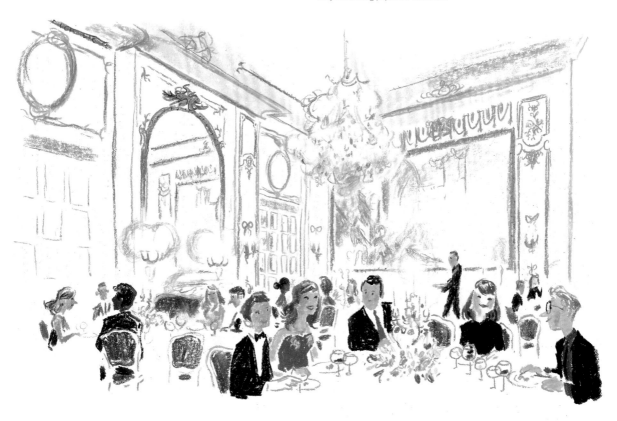

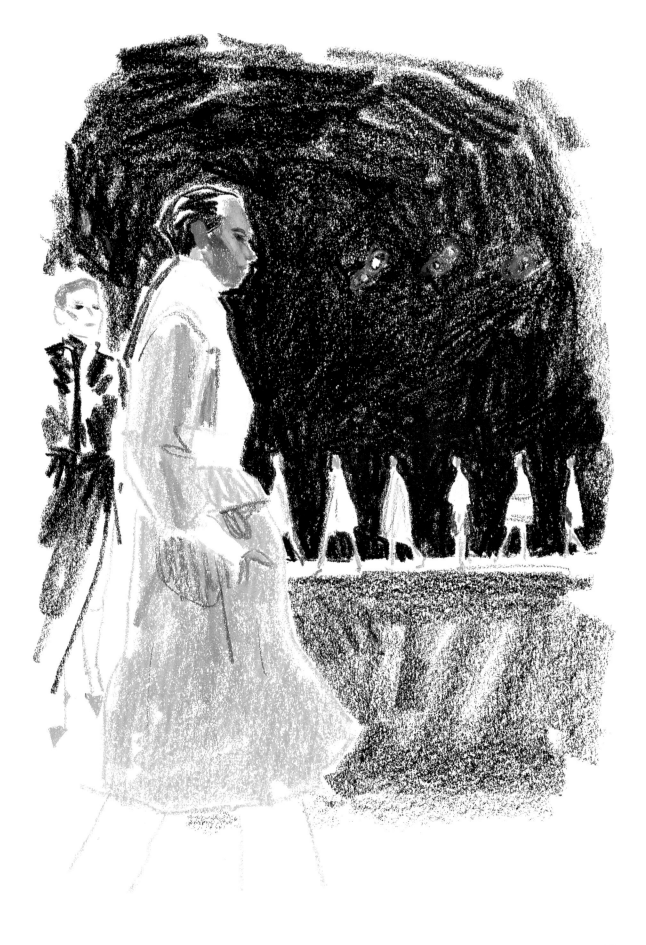

Previous pages:
Ritz's Windsor Suite, 2015, Neocolor
II crayons on 90g paper, approx.
25 x 15 cm (10 x 6 in).

Opposite:
*Coco Chanel for Harper's Bazaar
DE*, 2014, Neocolor II crayons
on 90g paper, 19 x 19 cm
(7½ x 7½ in).

Above left:
*Ploy Chava arriving at the Carven
show*, 2015, Neocolor II crayons on
90g paper, 21 x 14cm (8 x 6 in).

Above right:
*Marjan Eggers arriving at the
Margiela show*, 2014, Neocolor II
crayons on 90g paper, 21 x 14 cm
(8 x 6 in).

Jean-Philippe Delhomme

Born: 1959, Nanterre (France)
Lives: Paris/New York

French-born Jean-Philippe Delhomme's career has seamlessly combined illustration, fashion illustration, art (his paintings have been shown in Paris and New York), writing (he has published a number of novels and writes a regular column for *ZEITmagazin*) and now even photography and architecture. His highly popular blog, *The Unknown Hipster*, suggests a flâneur-type personality, whereas his output points towards a far more serious creative force.

The Unknown Hipster I started *The Unknown Hipster* when blog culture was just beginning to emerge as a new form of social media and people were fascinated by it. It was just as it is now with Twitter and Instagram. The nineties' equivalent would have been the craze for alternative fashion magazines.

I started this blog to mirror and parody the general craze for blogging – people being so serious about their own personas, so openly egotistic in their blogs (and being praised for it!). I thought it would be fun to create an anti-hero, *The Unknown Hipster*, who would speak in his own voice and mock all these clichés. Eventually, though, this character became a very sincere way of documenting things I was seeing for real, and the blog became an ideal means to make observations about the artists or designers I was really interested in, while keeping some distance and humour.

While most successful blogs were evolving from platforms for self-promotion to commercial enterprises, I always considered *The Unknown Hipster* as a totally free-form poetic project. I prefer to think of it as street art, or a free magazine: you're happy when it inspires people, without the need for it to be copied or to receive mass-media attention.

On magazine publication I've always loved magazines and consider them a great means with which to experiment, show pictures, write and speak to an audience in a more subtle way than with bigger and more commercial forms of media. I love the physical presence of a magazine; I love to see photographs printed full page, and having the time to browse through and stop to read a piece. It's quite different from swiping a mini-screen with your thumb to scroll down as quickly as you can, and looking at images with the mindlessness of an automatic cashier scanner.

I think good magazines can establish a real complicity with an audience and introduce a new aesthetic that is a departure from the more commercial, advertising-driven magazines. I also feel that the omnipresence of fashion, even in supposedly alternative or more underground magazines, is rather boring: why do they feel it's necessary, when they take pictures of people, to have them wearing brands? It's a real pity. Many small magazines, instead of looking cool and underground, look like the portfolios of their founders, hoping to be hired by *Vogue*.

Process I have no set creative process. It's not like a factory, where you assemble materials in a certain way, or a shop, where you buy from others to re-sell. It's more like a warehouse, where you can pick up your stock. It seems there's nothing ready ahead, and everything comes about in a rather mysterious and unpredictable way. For me it's more about reacting to things seen or read, or to the everyday life in a city. And above all, it's about being in the right state of mind.

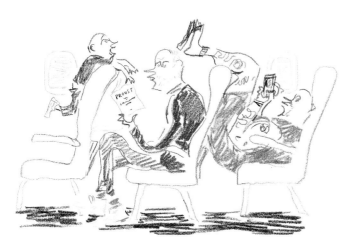

On the inconveniences of air travel, illustration for Delhomme's satirical monthly column for *L'Obs* magazine style supplement 'O', 2015, coloured pencil on paper, 21 x 29 cm (8 x 11½ in).

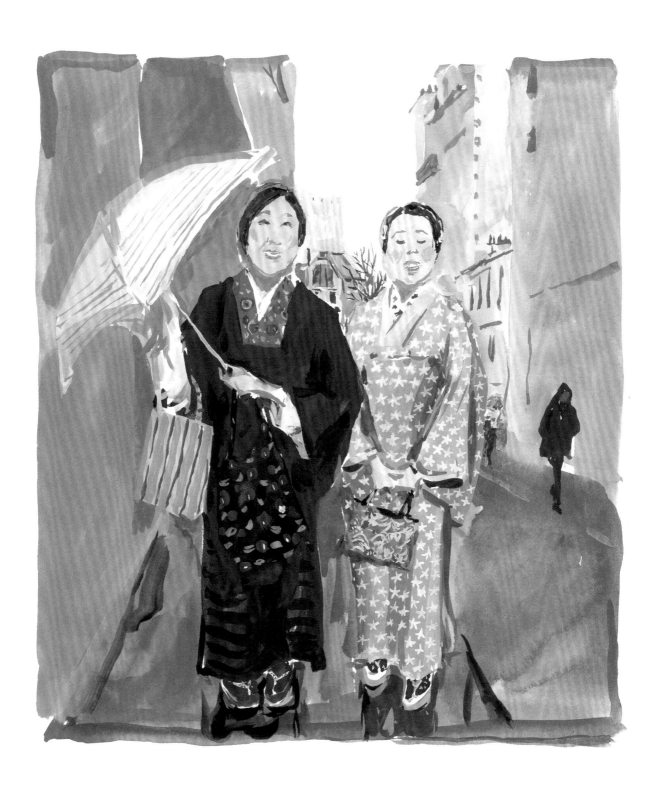

Women wearing kimonos on a rainy afternoon in Montparnasse, from Delhomme's 2015 weekly column 'Pariser Tagebuch' for ZEITmagazin, 2015, gouache on paper, 40 x 30 cm (16 x 12 in).

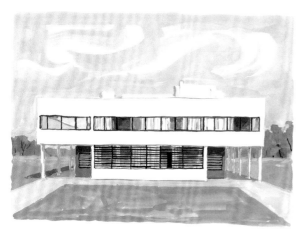

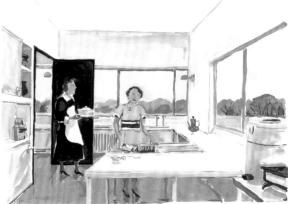

Top left:
Villa 'Les Heures Claires' designed by Le Corbusier, from the book *Les Heures Claires de la Villa Savoye*, Éditions des Quatre Chemins, 2015, gouache on paper, 30 x 40 cm (12 x 16 in).

Above left:
Le Corbusier designed villa 'Les Heures Claires' had frequent problems, here Mrs Savoye is checking on the leaks in the ramp, from the book *Les Heures Claires de la Villa Savoye*, Éditions des Quatre Chemins, 2015, gouache on paper, 30 x 40 cm (12 x 16 in).

Top right:
Mrs Savoye in her kitchen at the villa 'Les Heures Claires' designed by Le Corbusier, from the book *Les Heures Claires de la Villa Savoye*, Éditions des Quatre Chemins, 2015, gouache on paper, 30 x 40 cm (12 x 16 in).

Above right:
Pierre et Eugénie Savoye and their son Roger by the fire in their Le Corbusier designed house, from the book *Les Heures Claires de la Villa Savoye*, Éditions des Quatre Chemins, 2015, gouache on paper, 30 x 40 cm (12 x 16 in).

Saturday visitors in NY Chelsea
galleries, 2 women busy with their
iphones by Michael Heizer's 'Potato
Chip' at Gagosian Gallery, from
Delhomme's 2015 weekly column
'Pariser Tagebuch' for *ZEITmagazin*,
2015, gouache on paper,
30 x 40 cm (12 x 16 in).

Berluti Club Swann dinner: an extravagent
dinner given for an exclusive circle of Berluti
shoes owners, where guests has their shoes
brought back with a polish set at dessert, from
Delhomme's 2015 weekly column 'Pariser
Tagebuch' for *ZEITmagazin*, 2015, gouache
on paper, 30 x 40 cm (12 x 16 in).

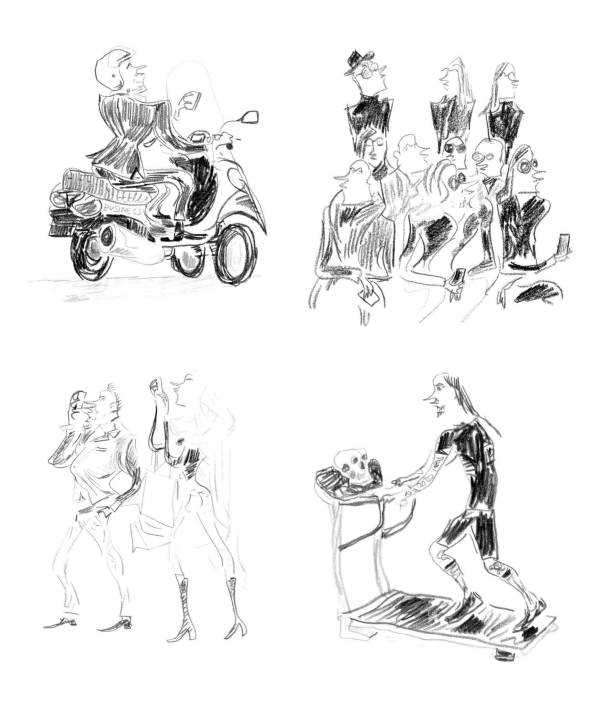

Top left:
The new entrepreneur and his 3 wheels scooter, illustration for Delhomme's satirical monthly column for *L'Obs* magazine style supplement 'O', 2015, coloured pencil, 21 x 29 cm (8 x 11½ in).

Above left:
The neo bourgeois, illustration for Delhomme's satirical monthly column for *L'Obs* magazine style supplement 'O', 2015, coloured pencil, 21 x 29 cm (8 x 11½ in).

Top right:
Fashion people at work, illustration for Delhomme's satirical monthly column for *L'Obs* magazine style supplement 'O', 2015, coloured pencil, 21 x 29 cm (8 x 11½ in).

Above right:
Health Goth, illustration for Delhomme's satirical monthly column for *L'Obs* magazine style supplement 'O', 2015, coloured pencil, 21 x 29 cm (8 x 11½ in).

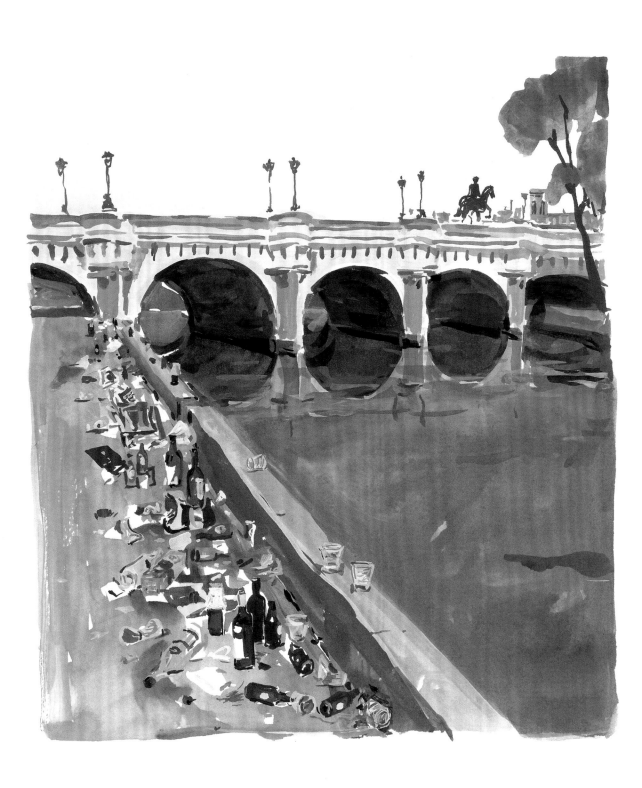

Sunday morning on the quay, near Pont Neuf, from Delhomme's 2015 weekly column 'Pariser Tagebuch' for *ZEITmagazin*, 2015, gouache on paper, 30 x 40 cm (12 x 16 in).

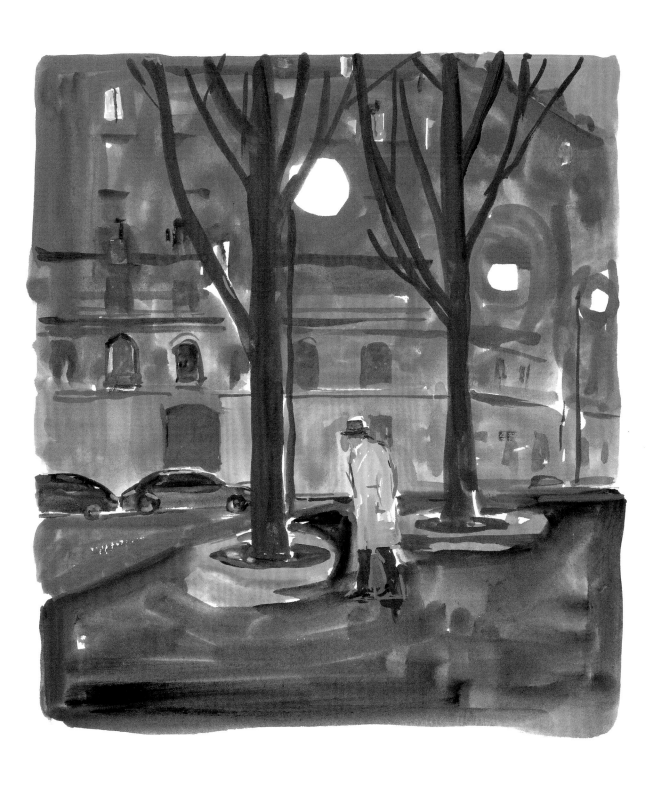

Sunday night, a tribute to Brassaï,
from Delhomme's 2015 weekly
column 'Pariser Tagebuch' for
ZEITmagazin, 2015, gouache on
paper, 30 x 40 cm (12 x 16 in).

Marion Deuchars

Born: 1964, Falkirk (UK)
Lives: London

**Marion Deuchars' trademark style
of hand-lettering has appeared on
a variety of items, from Royal Mail
stamps to Jamie Oliver cookbooks.
Starting out with painterly figurative
work influenced by the Scottish
School of painters, before moving
into more commercial graphic work,
Deuchars says that her practice
tends to 'shift every decade'.**

When to stop I do try to connect to the freedom that you see when a child draws: the way they attack the page in a big, sweeping stroke, without fear! Once my 5-year-old nephew painted this beautiful image, full of spontaneity and vibrant colour. I was so excited by it and said, 'Stop now, it looks great'. He ignored me and slowly turned his creation into dark brown mud. I felt a sense of despair, but then somehow he pulled that painting around and by the time he decided it was 'finished' it looked fantastic. The hardest thing to learn when making images is when to stop. It's all about confidence.

Process I love pure graphite, its velvety quality, its depth. It's so satisfying to draw with. I also like Quink writing ink, as it has an imperfect finish. I often use cheap paper because I scan much of my work. It frees me up, since it makes it throwaway and non-precious, but sometimes I use expensive gouache paint and Fabriano paper – if I'm making an actual artwork.

I have been working for 25 years – a lot has changed. Studios where people played with art materials on a desk have mostly been replaced by people sitting at a screen to produce work (I prefer to work standing up). Our studio was full of bike couriers, picking up work, delivering work, but that's gone. The phones used to ring all the time. Silence. The door used to buzz all the time, now it's fairly silent. Our work mainly came from London clients, now it comes from all over the world.

London It's an endless source of inspiration. I love its energy, its history, its parks. It's like living in the past and the present simultaneously. A street name conjures up so many stories. They say that every breath you take and every bite you swallow is composed of atoms that have been here for a long time, so romantically we are breathing the same air as Shakespeare. I live in Islington: it's full of Dickens' characters. The British Museum is also nearby. I am a member of many museums, galleries and theatres. It means if I have a spare hour, I can nip into one easily.

Trends When I did the D&AD annual review with Vince Frost many moons ago in hand-lettering, there was nothing around like it. Now hand-lettering is everywhere. It amazes me how long a trend lasts. I'd say it takes ten years before a 'new thing' comes along. I think there is a new energy in illustration now that looks very exciting and fresh. There also seems to be more diverse application of imagery. In the past, it was mainly print-based, but it has now leapt off the page!

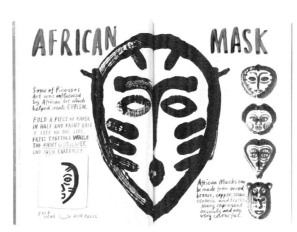

Left:
African Mask,
illustration from *Let's
Make Some Great Art*,
published by Laurence
King, 2012, acrylic
on paper printed in
black and two special
pantone colours,
21 x 29 cm
(8 x 11½ in).

Opposite:
Panda, 2014, three-
colour silk screen
on paper, 76 x 57 cm
(30 x 22 in).

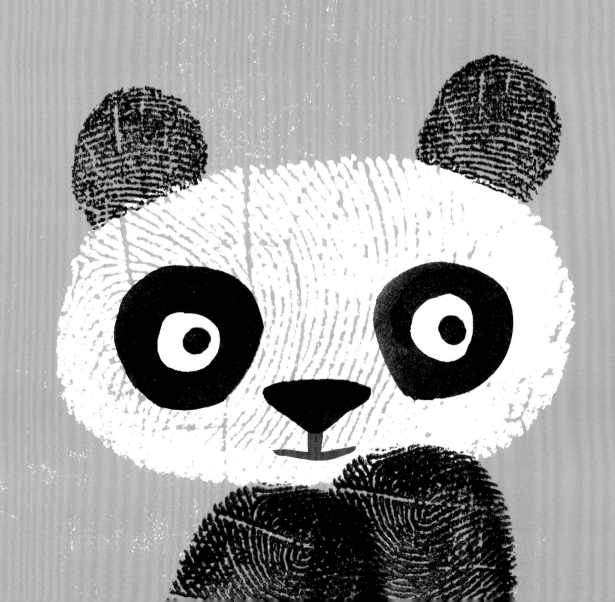

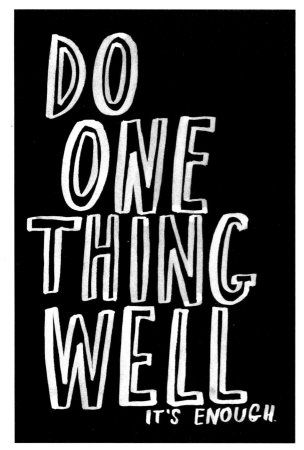

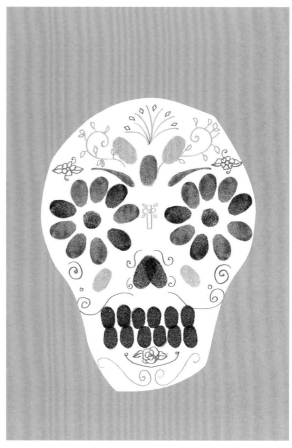

Above:
Do One Thing Well, 2014, poster
printed on handmade, heavyweight
Fabiano 5 Liscia paper,
76 x 51 cm (30 x 20 in).

Above:
Skull, poster for The Typographic
Circle, 2013, fingerprint ink printed
as CMYK, 84 x 59 cm (33 x 23 in).

Opposite:
Poster for Deuchars' 'Let's Make
Art' exhibition at The Park Gallery
(Falkirk, UK), 2014, CMYK poster,
84 x 59 cm (33 x 23 in).

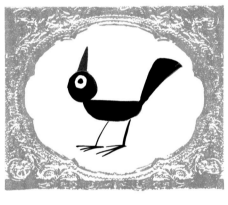

Marion Deuchars

Let's make ART

The Park Gallery 3rd May – 20th July 2014

Nathalie Du Pasquier

Born: 1957, Bordeaux
Lives: Milan

Nathalie Du Pasquier's life changed in 1979 when she arrived in Milan, fell in with the local design scene, and soon found herself completely addicted to the art of making textiles. With postmodernism at its height, she mingled with many other artists and became a founding member of the Memphis Group, an Italian architecture and design collective that created furniture, fabrics, ceramics, glass and metal objects from 1981 to 1987. Towards the end of the eighties, however, the collective disintegrated and Du Pasquier turned to painting instead.

Materials I use different materials and usually I do not mix them. If I do a drawing it is with coloured pencils or ink pen on paper, and if I paint it is with oil on canvas, paper or cardboard. If I build things, I do that by gluing together pieces of wood, and sometimes existing objects, and then I paint them with opaque acrylic.

I use the computer and digital camera to document my work. The computer allows me to compile my booklets, which I am quite involved in at the moment. The booklet is, first of all, a way of getting my work out there at a time when shows and sales are not so easy. It is a way of staying in touch with the world; they are cheap to produce and I can leave them in special bookshops. But they are also an opportunity to put together different elements of my work. This is a new aspect of my practice. It has allowed me to find a coherence in the different things I have done in the last 35 years. For many people these aspects of my work – the textiles, paintings, constructions, graphics – are contradictory. For me, however, they are not. Still, I find it tiring to be at the computer, facing a fantastic possibility of storing, organizing and printing images, which I will then cut out with scissors and glue on to paper!

Process Painting is my preferred activity. This is when my eyes, my hands and the memory of a technique work together without too much thought. In recent years I have spent more time on paper. The colours I use come naturally to me. They are not the result of a thinking process; maybe it is just instinct.

Milan I live in Milan – a big city, but not a metropolis. It was an important place for design when I arrived. I am not sure it still is: there is less and less manufacturing. The art scene here is not extraordinary, but is that important?

I like to look at architecture, too. I am interested in the science of positioning elements in a space. The composition of a drawing or a painting deals with these same questions. My work rotates around objects and space. They are the themes of much of my work. Even my more abstract pieces start from drawing impossible objects.

Far left:
Untitled, 2013, coloured pencil on paper, 70 x 50 cm (28 x 20 in).

Left:
Untitled, 2013, coloured pencil on paper, 70 x 50 cm (28 x 20 in).

Opposite:
Untitled, 2013, coloured pencil on paper, 100 x 70 cm (40 x 27½ in).

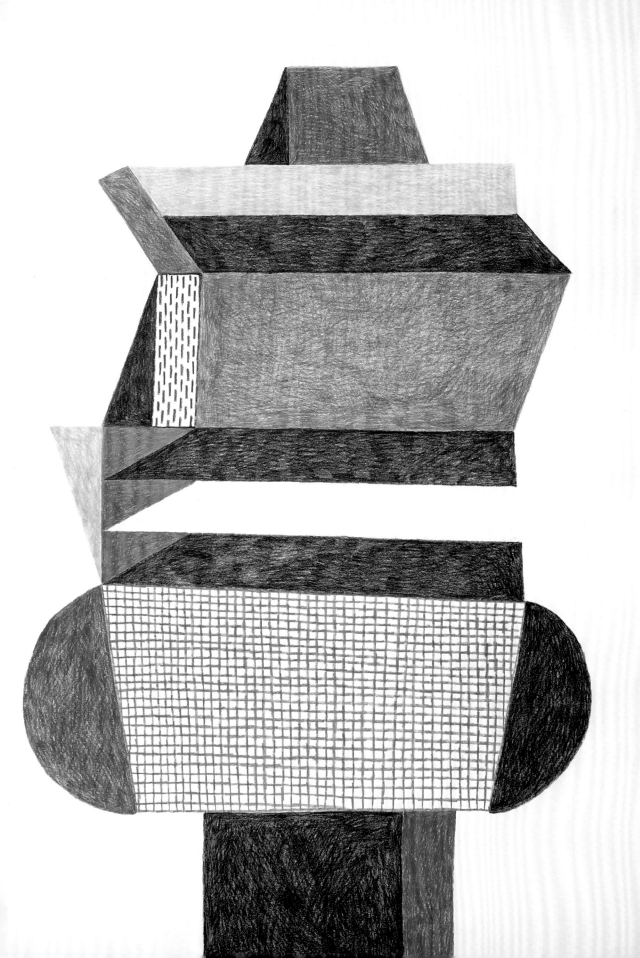

Opposite:
Untitled, 2013,
coloured pencil on
paper, 70 x 50 cm
(28 x 20 in).

Below left:
Untitled, 2013, black
pencil on paper,
30 x 21 cm (12 x 8 in).

Bottom left:
Untitled, 2013,
coloured pencil on
paper, 30 x 21 cm
(12 x 8 in).

Below right:
Untitled, 2013, black
pencil on paper,
30 x 21 cm
(12 x 8 in).

Bottom right:
Untitled, 2013,
coloured pencil on
paper, 30 x 21 cm
(12 x 8 in).

Juliette Etrivert

Born: 1989, Chartres (France)
Lives: Paris/Strasbourg

To avoid boredom, Juliette Etrivert alternates between styles of illustration that fuse elements extracted from humorous comics, sci-fi, classic paintings and screen-printing techniques. She says that she has always been inspired by the old Pulp aesthetic, superhero comics and the sci-fi authors and illustrators of the sixties, seventies and eighties, and that her current practice adds an element of eroticism to that aesthetic.

Education I attended the École Estienne in Paris, where I studied illustration and learned the basics of book-making. Then I joined the École Supérieure des Arts Décoratifs in Strasbourg: there I discovered the potential and diversity of silk screen-printing, and the integrity of free-minded illustration.

Process I mainly use nib/ink, or brushes/acrylic. For silk screen-printing, I scan paintings, material effects and hand-drawings into the computer and I mix them up. I work on as large a scale as possible so that I'm not afraid to get started. Silk screen-printing produces defects and blemishes – I love how physical it is. I also like bringing a sense of derision or absurdity to serious subjects.

Environment I have joined the rich underground scene of micro-publishing. It forces me to stay productive, and allows me to meet my audience and peers.

Opposite left:
Space Opera #1, 2014, acrylic,
airbrush and black ink on paper,
25 x 16 cm (10 x 6 in).

Opposite right:
Space Opera #2, 2014, acrylic,
airbrush and black ink on paper,
25 x 16 cm (10 x 6 in).

Above:
Family Portrait, 2014, acrylic and
airbrush on paper, 30 x 30 cm
(12 x 12 in).

Below:
Space Opera #3, 2014, acrylic,
airbrush and black ink on paper,
25 x 16 cm (10 x 6 in).

Opposite:
Ambush, 2014, acrylic and airbrush
on paper, 35 x 24 cm (14 x 9 in).

Daniel Frost

Born: 1984, Staffordshire (UK)
Lives: London

Daniel Frost used to worry that his finished works never looked as good as his sketches, until a friend suggested that he should just use the sketches themselves as the final pieces. He says that drawing in this way has not only allowed him to achieve the desired 'untreated' effect, but has also given him the confidence to make much bolder creative decisions.

Education It takes a long time to learn that there are no right or wrong answers in art, and that it has more to do with taste and opinion. Earlier on, I worried about what tutors thought was right or wrong, but as I continued I found that often the students also had opinions that were as valid as the tutors'.

Process Working with pencils and crayons are some of my favourite techniques: the quality of the marks feels unique. They have a naive texture and always looks (to me anyway) very fresh and instant. I don't think there are any other materials that feel quite like these. I also love the tone, depth and vividness that you get when you apply one colour over another.

I like the ease and speed of working digitally, too – there is something intuitive and free about drawing directly into the computer (the simplicity of picking colours, etc.) – but I think one of the downfalls is that things can be erased and reworked too easily, and you don't have moments when happy accidents occur.

Colours I'll always love the primaries: there is something simple but effective about them. They also symbolize youthfulness to me, I don't know why – maybe it's because these are the first colours you use as a child.

Art versus illustration I feel that illustration has changed a lot over the last couple of years. A few years ago, illustrations were seen only in certain formats (books, magazines, newspapers, etc.). But in the last couple of years, illustration has spread into different areas. You have artists like Andy Rementer and Parra and Jean Jullien, who are more like brands with very strong identities that people want to buy into. You can see their images on everything from trainers to watches. Maybe this has always been around, but it seems like there has been a boom in this kind of work in the last few years.

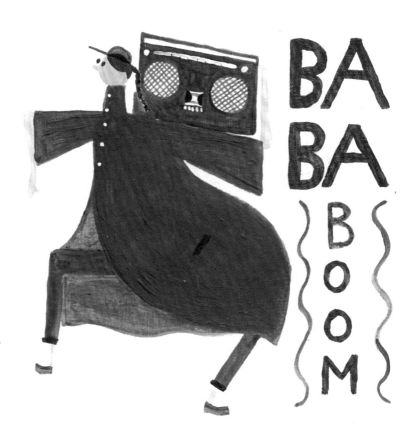

Right:
BA BA BOOM!, Daily Painting Project, 2014, acrylic on greyboard, 10 x 10 cm (4 x 4 in).

Opposite:
Cover illustration for *Cold North* magazine, 2014, mixed media, 30 x 21 cm (12 x 8 in).

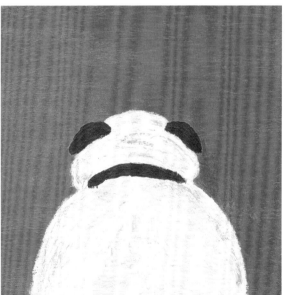

Opposite:
Sketch from the Glacier Express,
2015, Posca on paper,
21 x 14 cm (8 x 6 in).

Below left:
Onboard the Glacier Express, 2015,
Posca on paper, 42 x 30 cm
(16½ x 12 in).

Below right:
St Moritz, 2015, Posca on paper,
21 x 15 cm (8 x 6 in).

Si-Ying Fung

Born: 1985, Hamburg
Lives: Hamburg

Si-Ying Fung's work is semiotically charged: she sees her practice as the visual manifestation of language. 'If you change the structure of the way we communicate, or look at it from another perspective, you can see new forms.' It is these nuances and complications that she tries to bring across in the images that she creates, which she describes as 'not naturalistic'.

Education Before I decided I wanted to become an illustrator, I actually did Chinese Studies. Later on, I went to the University of Applied Sciences (HAW) in Hamburg, where I studied illustration, but fashion, textiles and costume design were also taught at the university. I suppose that's why I don't strictly consider my work just illustration – it is a mixture of everything I have ever done.

Process I have experimented with very different techniques, including photography, collage, print and video, but I always come back to drawing and painting. I just feel they are a lot more intimate, and you have a deeper relationship with what you create using those two methods.

Subject matter At the moment I'm interested in landscapes, both natural and artificial. The way landscapes change can tell us so much about our own identity and sense of space and place.

Faux-naive versus really naive My works are not naturalistic, but I don't try to make them look naive either. Maybe you can lose yourself in the process and concentrate at the same time; be focused and unfocused.

Below:
Illustration from *Nichts. Wir Fahren*, diploma project, 2012, oil pastel on paper, 59 x 84 cm (23 x 33 in).

Opposite:
Illustration from the 'Draußen in der Natur' series, 2014, oil pastel on paper, 30 x 21 cm (12 x 8 in).

Illustration from *Nichts. Wir Fahren*,
diploma project, 2012, oil pastel
on paper, 42 x 59 cm (16½ x 23 in).

Illustration from *Nichts. Wir Fahren*, diploma project, 2012, oil pastel on paper, 59 x 84 cm (23 x 33 in).

Louis Granet

Born: 1991, Talence (France)
Lives: Paris

'I am deeply in love with colours –
they all make me crazy,' says Louis
Granet. He occupies a liminal space
between disciplines, stressing that
he is neither a comic author nor an
illustrator. He prefers this position
because it allows him to explore his
style without constraints, and to
find new depths in his work.

Background While other children read novels, I would pore over art
catalogues before bedtime. My father, who is also an artist, always supported
my ambitions.

When I was a child, I drew without knowing where to go, just for the fun
of it. My studies taught me to really think about and control what I was doing.
It's been an exciting challenge to keep a balance between erratic fun and
discipline. I think it is important to de-mythologize the practice of drawing and
painting. It is important to keep the freedom of gesture, of movement, while
bearing in mind what we are doing and why.

Process I throw away almost 90 per cent of my work. For one drawing that
I deem 'successful' I have to burn ten others. I also use a lot of social media to
gauge how good or bad a work is. I am very sensitive to criticism, whether it's
positive or negative.

I hate working on one single drawing for a long period. To avoid this, I build
a comic board in the morning, then I dash to my atelier to paint on canvas,
and in the evening I work on a drawing on my computer. This allows me to get
a certain distance from what I am doing at any one time. In any case, I try to
produce about 20 drawings per day!

I am working as an assistant for the artist Stéphane Calais, and he has
changed my artistic life profoundly. I often pass by his atelier to show him
what I am doing. Sometimes, I leave the place completely shaken up, but with
an enormous urge to keep on drawing.

Clovis at basketball, 2014,
felt-tip pen on paper, 30 x 42 cm
(12 x 16½ in).

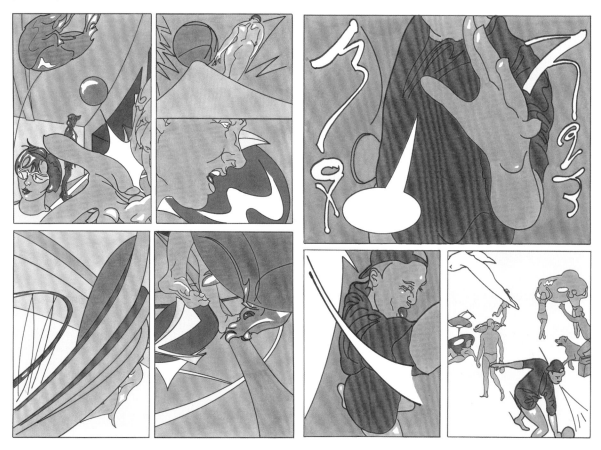

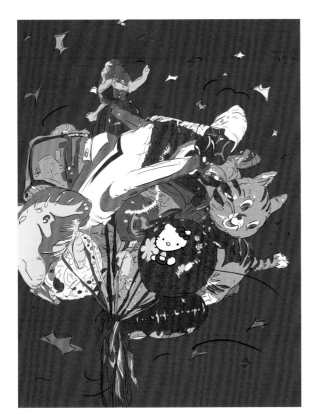

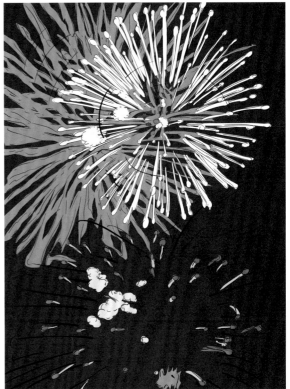

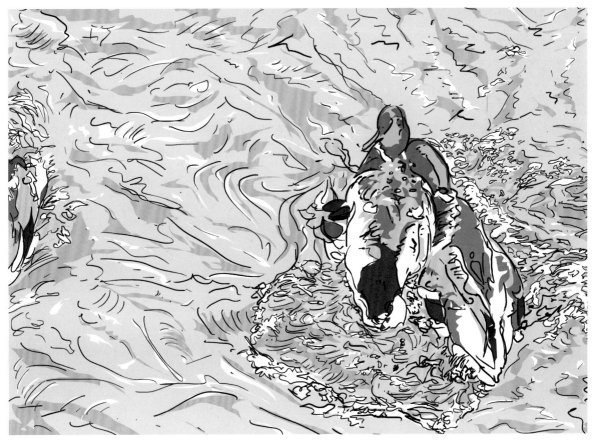

Top left:
J'pête les plombs, 'Georges 300 – summer collection', 2015, paper printing, 80 x 60 cm (31½ x 23½ in).

Top right:
Feu! feu! feu!, 'Georges 300 – summer collection', 2015, paper printing, 80 x 60 cm (31½ x 23½ in).

Above:
Untitled, 'Georges 300 – summer collection', 2015, paper printing, 60 x 80 cm (23½ x 31½ in).

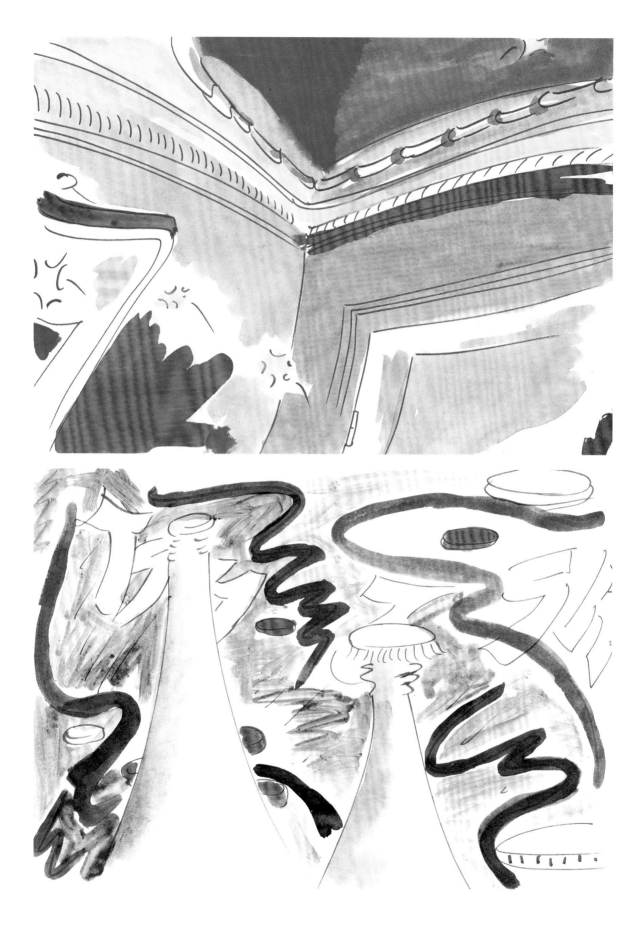

Opposite top:
Untitled, 2015, watercolour
on paper, 21 x 30 cm (8 x 12 in).

Opposite bottom:
Untitled, 2015, watercolour
on paper, 21 x 30 cm (8 x 12 in).

Below left:
Untitled, 2015, felt-tip pen on paper,
30 x 21 cm (12 x 8 in).

Below right:
Untitled, 2015, felt-tip pen on paper,
30 x 21 cm (12 x 8 in).

Above:
Untitled, 2015, oil and acrylic on
canvas, 162 x 130 cm (64 x 51 in).

Opposite:
Untitled, 2015, oil and acrylic on
canvas, 195 x 130 cm (77 x 51 in).

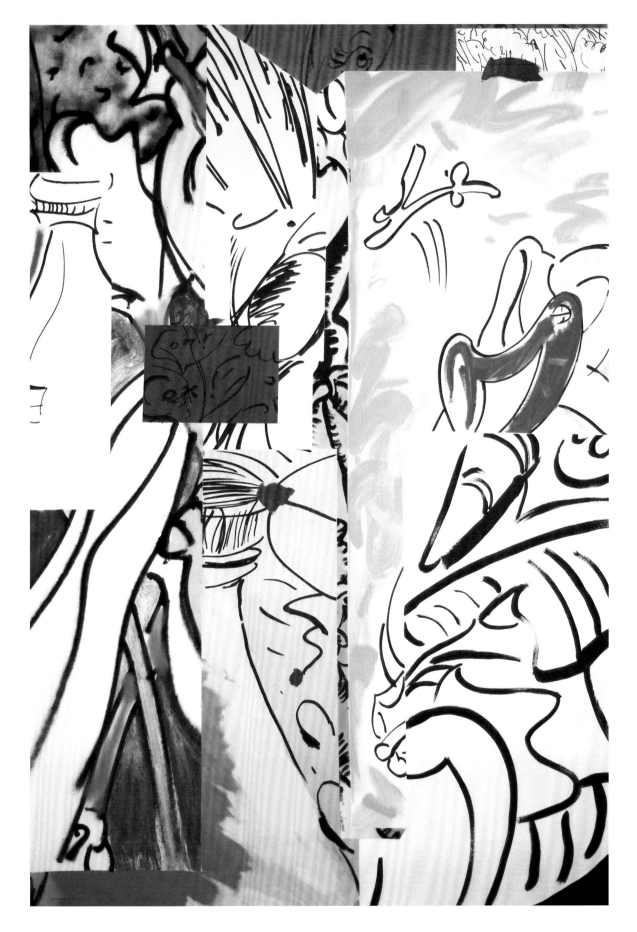

Sofie Grevelius

Born: 1981, Lund (Sweden)
Lives: London/Kungshamn (Sweden)

Sofie Grevelius' work is inspired by the fortuitous landscapes that make up a city: road markings, scaffolding, building facades, ventilation systems, signage, pipes and physical fixtures such as railings and doors. Musing that 'everything is passing, everyone is on the move, things overlap, layer, create shapes and unplanned meanings,' she is interested in the relationship between the planned and manufactured versus the haphazard and ephemeral.

Philosophy I am interested in mimicking everyday shapes and objects in an attempt to accentuate their presence in our lives. I try to understand their effect on us. The French twentieth-century philosopher Maurice Blanchot described the everyday as something we never see for a first time, but always see again. I would like my work to have a similar quality.

Process Everything begins with everyday life, and the techniques I use are embedded therein. My camera phone has begun to act almost as a third eye. The photographs serve as an instruction manual to my practice. They become recurrent leitmotifs, a fascination with the chance encounter, playful sightings, the casual beauty of the everyday. However, it is through drawing that the first real translation of reality takes place. I break down what I have seen or captured with my camera phone, and turn it into a new visual expression. To me, drawing is thinking.

The selection process, and the process of refining, begins in the run-up to a show. The space in which the work is shown plays a major part in it. It is like creating the frames for a new city, in parallel to the one just outside the gallery space, with its own rules and relationships, and its own beautiful and strange infrastructure.

Left:
SCREEN 1, 2013,
screen print on paper,
30 x 21 cm (12 x 8 in).

Opposite:
RED NET, 2013, soft
pastel on paper,
84 x 60 cm
(33 x 24 in).

The Skies, 2012,
soft pastel on paper,
42 x 30 cm (16½ x 12 in).

How it Hangs, 2013, soft pastel on
paper, 60 x 42 cm (24 x 16½ in).

Netting, 2014, screen print on
paper, 84 x 60 cm (33 x 24 in).

And everything in between, 2012.
lithograph on paper, 80 x 60 cm
(31½ x 23½ in).

Kim Hiorthøy

Born: 1973, Trondheim (Norway)
Lives: Berlin/Oslo

The protean Kim Hiorthøy has an impressive repertoire of works across different disciplines that would make most artists green with envy: starting out in music, with several albums produced by Smalltown Supersound, he later moved on to make a career in the visual arts. 'I'm 42, so if I take everything up until now as "my background", then it's many different things,' he says. 'I've worked as a graphic designer and illustrator, and as a cinematographer; I've written music for film and dance, released records of music and played live shows; and I've made art and shown in galleries and museums. Most recently I've studied choreography and tried to work with dance, or a kind of dance. I think what I do now is mostly a continuation of what I used to do when I was a kid.'

Style I don't know what my personal style is. I know that when I was young I did a lot of trying to copy things that I saw, that I liked. I think if you try to copy other people's work and you're not very good at copying, maybe you end up inventing your own style by default. But the surest way is probably just to work and work and work, and to be curious and try to figure out what you're doing while it's happening – and if you find out, then to try and take it further.

There's a connection for sure between the kind of drawings I made as a child and what I do now. I think it's something I don't like to admit and also often feel embarrassed about. But I also think feeling embarrassed about it is stupid.

Process I try not to use anything too regularly, but if I don't know what I'm doing I often resort to habit, usually with little success. I do use the computer a lot. Computers didn't used to be fast enough, but now my only grudge is that they make me sit down too much. And also that they give me access to the internet, so I get distracted.

I discard a lot of work. Sometimes everything. My 'method' is usually just intuition, at least at the beginning. Far enough past a deadline, the method probably becomes more utilitarian.

I think I generally start by trying to do something different from what I did last, which often doesn't work at all. I usually carry around images or ideas in my head that I'm waiting to try, so given the chance I'll start from one of those. There's always a lot of self-doubt. In terms of time, if the idea doesn't require very labour-intensive work, I'm usually quite fast. Sometimes too fast, perhaps. If I know what I want to do, I'll make a plan and stick to it – which I much prefer to not knowing and having to find out as I go.

Inspiration Lately I've been more inspired by work that is not at all like the work I do. That's both frustrating and kind of exciting. I don't go to exhibitions very often, but I buy a lot of books. My main interests are probably comedy, storytelling and metaphysics, and how we think about death.

Trends I don't think I've really been part of something in that way. I'd like to have been. There was a period around maybe 1994 to 1996 when the availability of computers and software made it possible for complete amateurs (me) to get work doing actual graphic design that looked weird and new. I think I kind of felt part of that then. At least in Norway. That was fun.

Assignments 1, 2013, graphite on paper, 33 x 43 cm (13 x 17 in).

Top left:
The People's People, 2014,
watercolour on photocopy,
20 x 19 cm (8 x 7½ in).

Above left:
Nose and Mouth, 2008, collage,
31 x 31 cm (12 x 12 in).

Top right:
The Wait, 2012, gouche on paper,
31 x 31 cm (12 x 12 in).

Above right:
All in, 2011, ink and pencil on
photocopy, 31 x 31 cm (12 x 12 in).

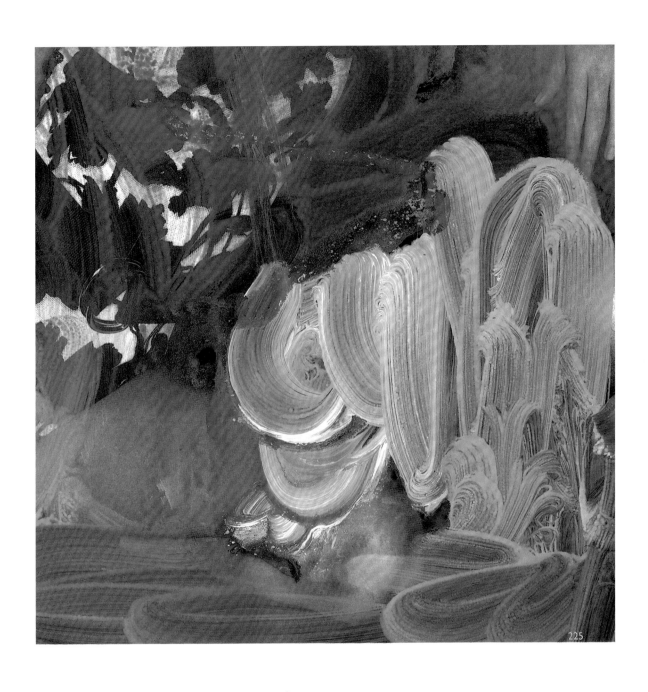

225

Previous pages:
Butter, 2015, gouache on paper and collage, 35 x 52 cm (14 x 20½ in).

Opposite top:
Omitted Pastoral Scene, 2014, gouache on paper with tape. 35 x 52 cm (14 x 20½ in).

Opposite bottom:
Runner-up, 2013, graphite on card/photograph, 35 x 52 cm (14 x 20½ in).

Above:
Popular Imagination, 2011, gouache on magazine page, 31 x 31 cm (12 x 12 in).

107

Masanao Hirayama

Born: 1976, Kobe (Japan)
Lives: Tokyo

Masanao Hirayama started his
career as an illustrator in 2002,
but has been making art since
2010. The candour of his process
and the apparent carelessness of
his lines are just a facade, hiding a
very precise and methodical mind.
His work has become best known
in Europe for the zines that have
been coming out through the cult
Swiss publishing house Nieves.
The book *5400* (2014) was based
on his performance drawing with
a plush pig, whereas *Masterpiece
Coloring Book* was produced with
Ken Kagami and is possibly the
most confusing colouring book
ever published. His replies are as
confounding as his work …

Background I did not undertake an art education at a school.

**Is there a connection between what you are doing now and the idea of
making art as a child?** I have no idea.

Process I regularly use a pen, paper, an acrylic and a canvas. I do discard
work sometimes. That is because of the limitations of the space I use. I don't
have any specific preferences in terms of materials, but I usually work in black
and white. Things can be both carefully planned and instinctive.

Do you have a particular relationship with certain techniques? Yes and no.

What are your main areas of interest as an artist? I would like to find that
out, too.

On the difference between art and illustration Art is freedom. Illustration is
companies' propaganda.

Below:
3793, 2011, acrylic on paper,
30 x 42 cm (12 x 16½ in).

Opposite:
5497, 2014, pen and pencil on
paper, 30 x 21 cm (12 x 8 in).

ITS OUR
PLEAQURE
TO SSRVE
YOU

Below left:
4166-1, 2012, pen and pencil on paper, 30 x 42 cm (12 x 16½ in).

Bottom left:
Basel, Switzerland (4709), 2013, pen and pencil on paper, 21 x 30 cm (8 x 12 in).

Below right:
3792, 2011, acrylic on paper, 30 x 42 cm (12 x 16½ in).

Bottom right:
3627, 2011, pen and pencil on paper, 30 x 42 cm (12 x 16½ in).

Opposite:
4071, 2012, pen and pencil on paper, 30 x 21 cm (12 x 8 in).

Overleaf:
3625, 2011, pencil on paper, 30 x 42 cm (12 x 16½ in).

Kyu Hwang

Born: 1980, Seoul
Lives: Seoul

The travel bug bit Kyu Hwang at a young age, and he has spent most of his life travelling between England, Germany, Hungary, Canada and Korea. He spent about eleven years in Europe, where he was first exposed to European art, but it was not until later, at art school, that his style became more distinctive.

Seoul I attended the Hungarian Academy of Fine Arts in Budapest for a year, then transferred to Emily Carr University of Art and Design (ECUAD) in Vancouver, where I received my Bachelor of Fine Arts. After ECUAD, I spent about four years in Vancouver. I was a part of an artistic community there, even if the scene was mostly formed of locals. I have since moved back to Seoul, and have had to start again. The rent in Seoul is insane, so I've had to rent a studio about an hour outside the city. It's nice and quiet, but there's nothing remotely resembling an artistic community. These days, most of my art consumption and artistic interaction comes from the internet. It's obviously nothing like the real thing, but it has allowed me to connect to a much broader art scene and audience.

Process My work is like an endless pursuit of the past, trying to get back that raw and naive way of seeing and making things.

My drawing techniques are time-consuming and repetitive. There's a meditative quality to my process. I usually make myself a pot of coffee, put on some Radiohead on the stereo and empty my mind while I draw.

My favourite material is definitely graphite. To me, it's the most basic material to draw with. Everyone is familiar with pencils, and that helps make graphite-based work more approachable than, say, an oil painting. I use the computer a bit for my mixed-media prints, mostly because I can create very flat, consistent colours to contrast against the textures of my graphite work.

Since I work with graphite a lot, I prefer working in shades to working in colour. Even when painting, I like using darker hues like ultramarine blue, raw umber and blacks.

Opposite:
Cloud, 2013, giclee print on paper,
20 x 30 cm (8 x 11 in).

Below:
Go Away, 2011, graphite on coffee-
stained paper, 20 x 25 cm (8 x 10 in).

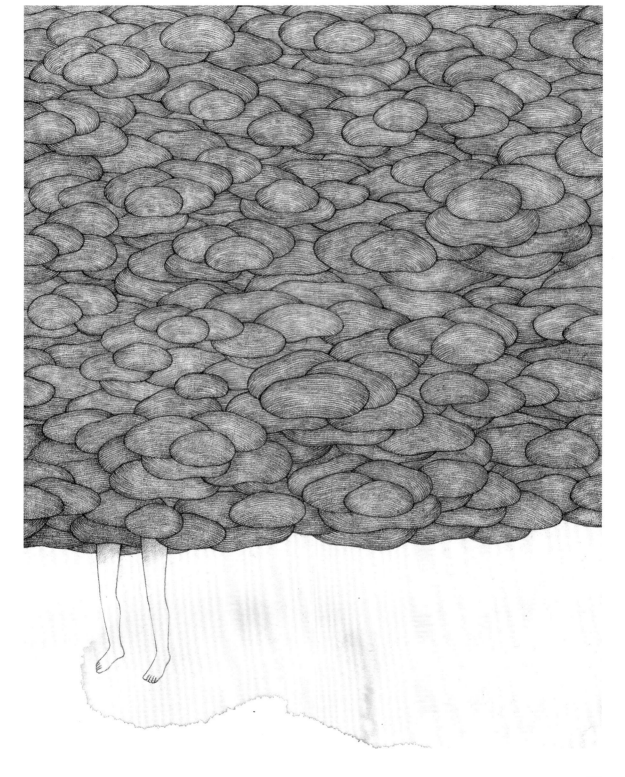

Below left:
Cloud, 2012, oil on canvas,
53 x 41 cm (21 x 16 in).

Bottom left:
Tree Stumps, 2012, oil on canvas,
66 x 51 cm (26 x 20 in).

Below right:
Cloud, 2012, oil on canvas,
117 x 91 cm (46 x 36 in).

Bottom right:
Fuc_ Tree, 2012, oil on canvas,
91 x 74 cm (36 x 29 in).

Opposite:
Cloud, 2012, oil on canvas,
91 x 74 cm (36 x 29 in).

Marie Jacotey

Born: 1988, Paris
Lives: London

Marie Jacotey relates her current practice to a childlike delight in creating images and playing with materials. Art school in Paris (L'École Nationale Supérieure des Arts Décoratifs) and an MA in printmaking at the Royal College of Arts in London gave her the opportunity to take this one step further and develop a personal style.

Process When drawing, I try to enjoy it as I would have as a kid, although nowadays I also think about the overall composition. I try to reach a balance between things left 'loose', or childlike, and things that are more controlled. I guess one of the effects of that tension is an unsettling feeling for the viewer, who can't tell how genuinely naive the whole thing is.

I take notes every day, drawn and written, inspired by whatever, really – something someone said, a nice pattern I've spotted, a night out at the pub, a walk in the countryside, random images from the internet. One image can take me from 15 minutes to a week, depending on size, medium, level of complexity. Some ensembles of work can even take me months to complete. I plan things, but loosely enough that I still get a sense of surprise and spontaneity in the making of the work.

Materials and technique I use pens, pencils and brushes on flat surfaces such as paper, plaster, aluminium boards or plastic. That said, everything starts with a pen and a bit of paper.

For my degree show at the RCA I started a series of oil paintings on plastic sheets, and I was really keen on their materiality. It created light, foldable works that could be hung using just static electricity. Lately, I have been developing new works on plaster and, I must say, it is an amazing medium; I presented a series of 58 of these at the Hannah Barry Gallery in late 2014. I am also a huge fan of coloured pencils, which I've used forever.

Colours I love colours! I seldom work in black and white. Over time I become particularly keen on certain colour combinations. At the moment I use a rather electric combo of bright yellow, vivid orangey-red and light blue a lot.

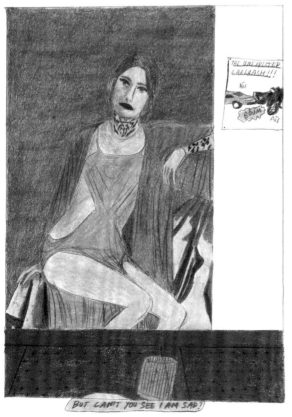

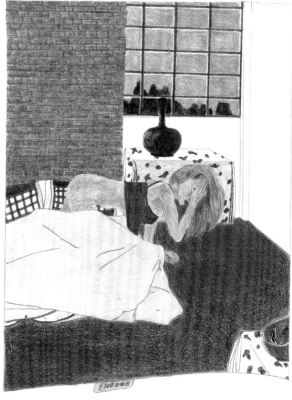

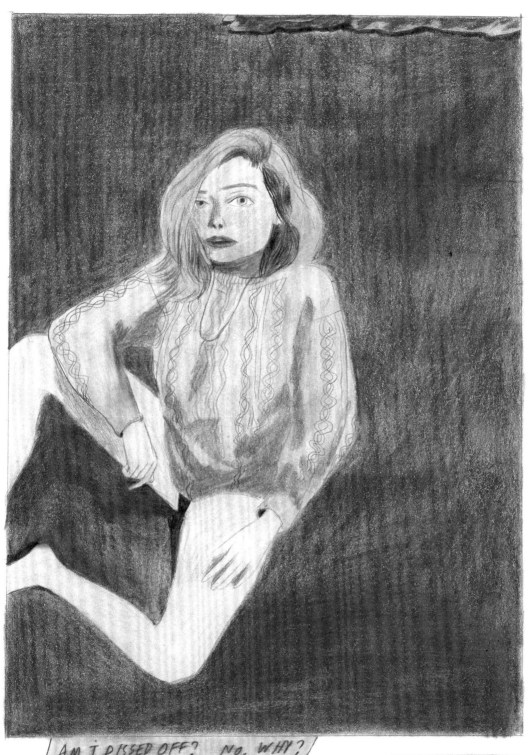

AM I PISSED OFF? NO, WHY?
DO I LOOK PISSED OFF? WELL, YOU'RE KIND OF
PISSING ME OFF RIGHT NOW.

Opposite left:
But can't you see I am sad?,
from 'BE YOUNG, BE WILD,
BE DESPERATE', 2013–present,
coloured pencils on paper,
23 x 19 cm (9 x 7½ in).

Opposite right:
Enough, from 'BE YOUNG, BE WILD,
BE DESPERATE', 2013–present,
coloured pencils on paper,
23 x 19 cm (9 x 7½ in).

Above:
Am I pissed off? from 'BE YOUNG,
BE WILD, BE DESPERATE', 2013–
present, 23 x 18.5 cm (9 x 7 in).

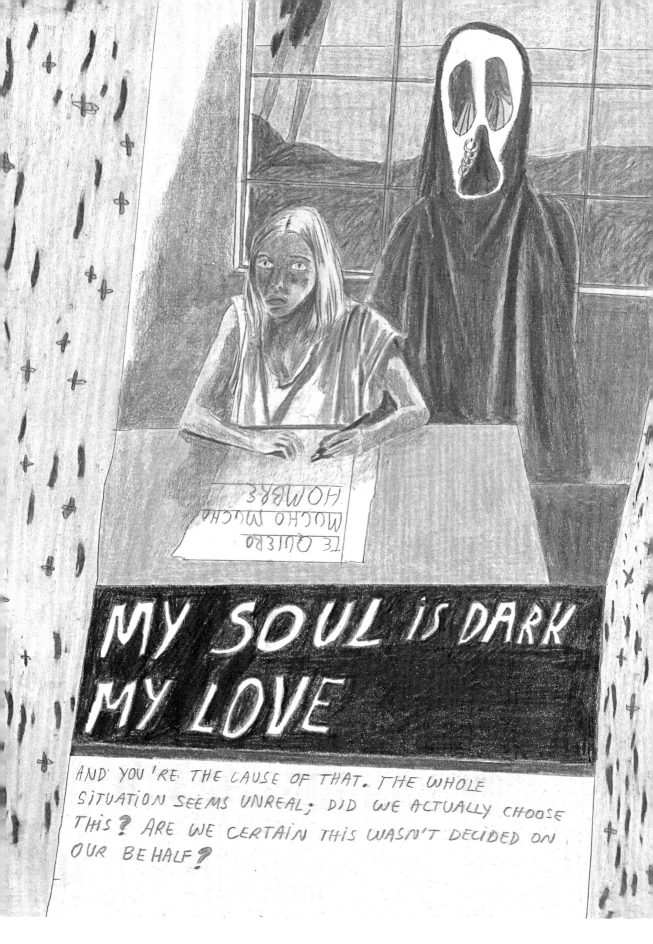

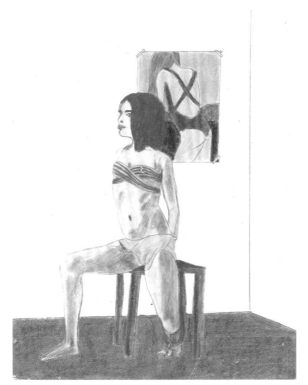

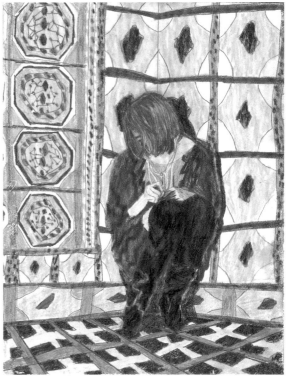

Opposite:
My soul is dark, from 'Dear love who should have been forever mine', 2015, 28 x 21 cm (11 x 8 in).

Above left:
Everything I do, I do for you, from 'GETTING OVER YOU', 2014, coloured pencils on plaster, 14 x 11 x 1 cm (5½ x 4 x ½ in).

Above right:
Collapsing at any moment disfigured by grief, from 'GETTING OVER YOU', 2014, coloured pencils on plaster, 14 x 11 x 1 cm (5½ x 4 x ½ in).

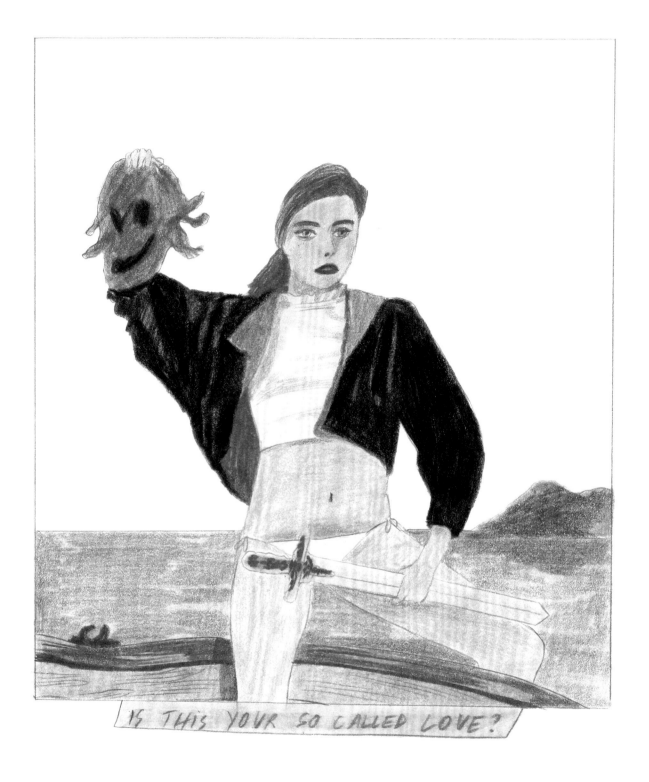

Is this love?, from 'BE YOUNG, BE WILD, BE DESPERATE', 2013–present, 23 x 18.5 cm (9 x 7 in).

Him at work, from 'Dear love who
should have been forever mine',
2015, 28 x 21 cm (11 x 8 in).

Faye Coral Johnson

Born: 1988, Manchester (UK)
Lives: Manchester

Faye Coral Johnson's work comprises doodles and scrawls that are not dissimilar to what one might find on the desk of a child. She emulates the artless 'organic style of drawing' that little children have, and enjoys putting incongruous images together to create visual non-sequiturs.

Process I like the idea of drawing what I think, not how I think I'm meant to think. I draw loosely and subconsciously, and I don't treat my drawings like precious objects. It's an integral part of my creative process to cut up drawings freely and mix them up. In this way, I can edit them to no end.

Inspiration I love to look at children's drawings, and what they choose to draw is especially interesting to me. With boys in particular, you see recurring motifs such as film characters, computer games, guns, cars, bugs and people fighting. If you put all these together you'd have a pretty hilarious picture – that's what my work is about, conveying the idea that we shouldn't take ourselves too seriously. I guess I'm also very much influenced by my grandfather, who used to paint lots of strange and funny things. I'll always remember how he painted a man dressed as Santa Claus walking down a dark alley carrying an elephant's head.

Below:
Tape cover for Irma Ved, *Deep Sea Fish* album, 2014, 6B pencil on paper, each 10 x 7 cm (4 x 3 in).

Opposite:
Back cover of *Index*, published by Café Royal Books, 2014, 6B pencil and digital collage on paper, 21 x 15 cm (8 x 6 in).

Overleaf:
Pages from zine *Humm Buzz Drone*, published by Nieves, 2014, 6B pencil and digital collage on paper, each 21 x 15 cm (8 x 6 in).

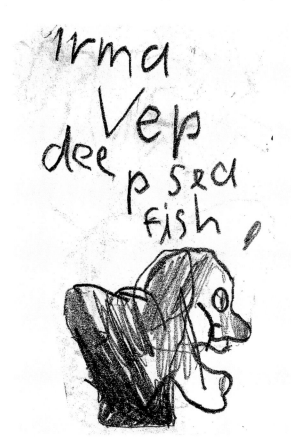

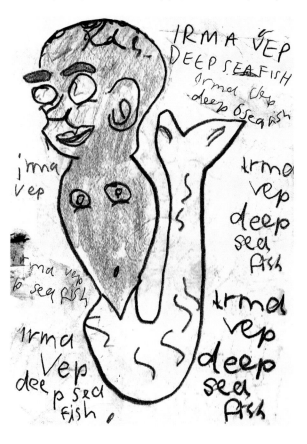

Misaki Kawai

Born: 1978, Kagawa (Japan)
Lives: New York

The works of Japanese artist Misaki Kawai espouse creative expression in its simplest form. She has been making art 'since [she] was in diapers', and credits her playful approach to her environment at home as a child, which involved puppet shows and other handmade activities.

Process My way of making art has not changed, but my grandmother has said my lines are getting wobblier. I like using paper, paint, fabric, fur and food. In fact, I can use anything around me in my work. For example, I paint with a fluffy raccoon tail, and I use my electric brain to edit music and videos.

I work fast, without planning in advance, and I never know how a sketch will turn out. If there is a mistake, even better – it gives my work more character. I am particularly inspired by children's art and outsider art. I also like comedy, because I am from a village in Japan where comedy is a huge deal.

These days I am making fewer works than before. I spend more time now travelling and dreaming up new ideas so that when I actually begin a new work, it's more special than ever before.

Style and colours I didn't used to like black, but now I love black with all other colours. But I don't have any black underwear or clothes yet.

I'm not sure how to describe my practice. It is fuzzy and tofu-like. As for me, I am from a rice ball planet. Very steamy and sticky.

Someday I would like to live in a real cave with cavemen on an island. I would use their beards to paint on the walls of the cave. Would anyone like to visit?

Opposite:
Installation view: Marugame Genichiro-Inokuma
Museuem of Contemporary Art (Japan).
[wall] *Max*, 2004, yarn, wood and plastic,
120 x 300 x 15 cm (47 x 118 x 6 in).
[floor] *Mini Arty*, 2014, yarn, wood and plastic,
79 x 101 x 36 cm (31 x 40 x 14 in).

Above:
Caveman Island, 2014, acrylic on
canvas, 203 x 152 cm (80 x 60 in).

Wonder Puppy, 2010,
acrylic, cardboard and fabric,
91 x 91 cm (36 x 36 in).

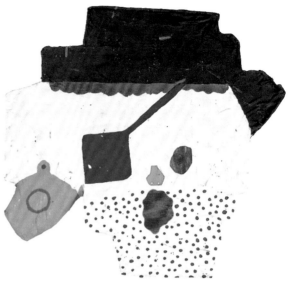

Top left:
Sad Girl, 2008, acrylic,
cardboard and fabric,
71 x 71 x 8 cm (30 x 30 x 3 in).

Above left:
Untitled, 2007, acrylic,
cardboard and fabric,
86 x 94 x 7 cm (34 x 37 x 3 in).

Top right:
Pirate Donut Ring, 2007,
acrylic, cardboard and fabric,
79 x 86 x 6 cm (31 x 34 x 2 in).

Above right:
Untitled, 2007, acrylic,
cardboard and fabric,
59 x 78 x 6 cm (23 x 31 x 2 in).

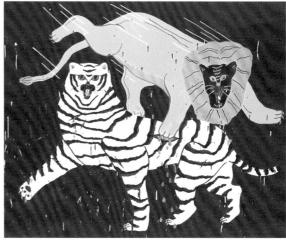

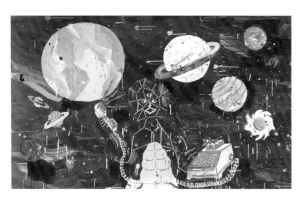

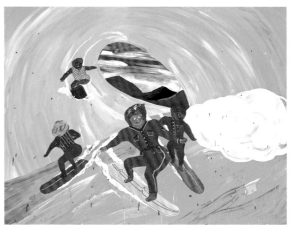

Top left:
Gray Bird Lover, 2007, acrylic,
fabric and paper on canvas,
91 x 97 cm (36 x 38 in).

Above left:
Universal Telecom, 2008,
acrylic, fabric and paper on canvas,
102 x 205 cm (40 x 81 in).

Top right:
Fuzzy Love, 2007, acrylic,
fabric and paper on canvas,
122 x 152 cm (48 x 60 in).

Above right:
Surf Club, 2008, acrylic,
cardboard and fabric,
152 x 203 cm (60 x 80 in).

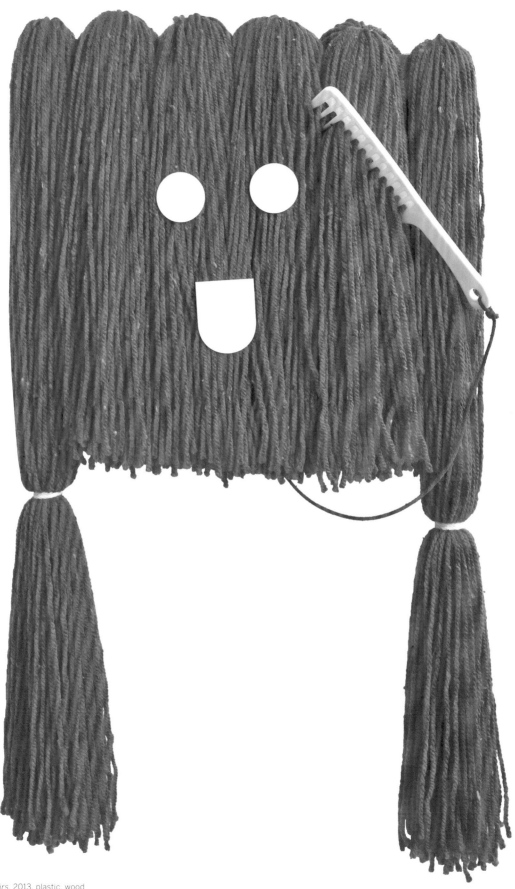

Noodle Hairs, 2013, plastic, wood and yarn, 76 x 51 cm (30 x 20 in).

Anna Kövecses

Born: 1988, Győr (Hungary)
Lives: Corfu (Greece) and Hungary

Anna Kövecses never underwent a formal art education: she became a mother at the age of 20 and felt she would not have been able to 'balance a baby, work and school', so instead she just 'read tons of art books and attempted many different techniques'. While graphic design helped her learn how to pare down her ideas, she also began to seek out a 'larger canvas' and greater creative freedom. Illustration became her outlet for this growing need, although she is still 'trying to tell short stories in a simple and playful language, with the fewest possible visual elements'.

Process I use acrylic paint, oil pastel, clay, felt and paper. I had to invent a way of merging art with family time, so my daughter and I started spending our afternoons outside, painting landscapes on sunny hilltops and wild seashores.

I have recently started using colours that occur in nature, like different shades of green, blue and brown, and a skin-tone pink. But I also have my 'primary colours phases', when everything revolves around red, blue and yellow.

As I have a very active family life I cannot get deeply involved with a project for countless hours. So I developed the habit of multitasking, planning a project in my head while nursing my baby, or making sketches in the car while we're travelling. I also have a rule about trying to capture the very first idea I have when starting work on a project – it always turns out to be better than what hours of brain-work can achieve.

Environment I live in a small town, so physically there's not much of a contemporary art scene around me, but since I'm a child of the internet era I'm metaphorically surrounded by the global art world. I love exploring how small independent groups of people get connected to art in unexpected ways. They get utterly creative with even limited resources and come up with fresh and unexpected outcomes. They might be curators of art blogs or publishers of indie magazines or makers of handmade rugs. I like drawing inspiration from this experimental spirit and applying it to my own work.

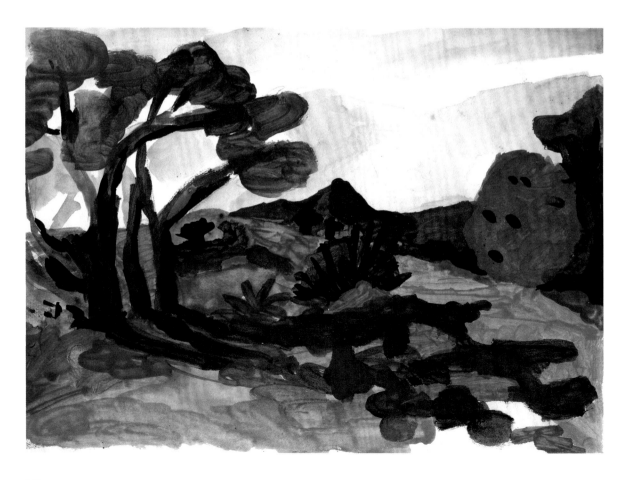

Opposite:
Hilltop near our home, personal
work, 2015, gouache on paper,
21 x 29 cm (8 x 11 in)

Above:
Untitled drawing, personal work,
2015, oil pastel on paper,
30 x 22 cm (12 x 9 in).

1.

6.

5.

4.

3.

2.

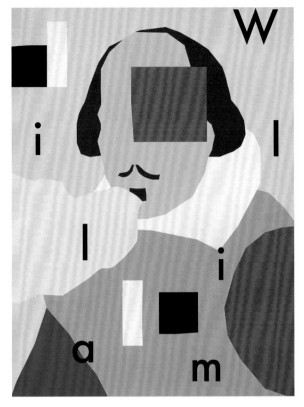

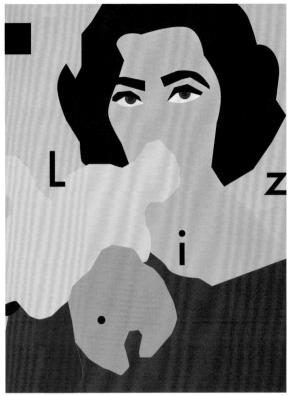

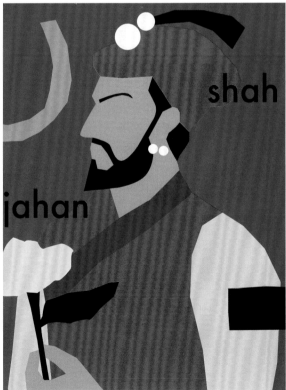

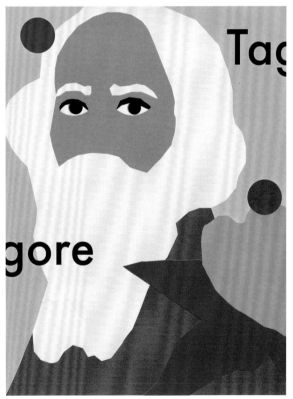

Opposite:
Coloradore 006,
personal work, 2012,
digital, 28 x 22 cm
(11 x 9 in).

Top left:
William Shakespeare,
Milk X magazine, 2014,
digital, 28 x 21 cm
(11 x 8 in).

Above left:
Rabindranath Tagore,
Milk X magazine, 2014,
digital, 28 x 21 cm
(11 x 8 in).

Top right:
Liz Taylor, *Milk X*
magazine, 2014,
digital, 28 x 21 cm
(11 x 8 in).

Above right:
Shah Jahan, *Milk
X* magazine, 2014,
digital, 28 x 21 cm
(11 x 8 in).

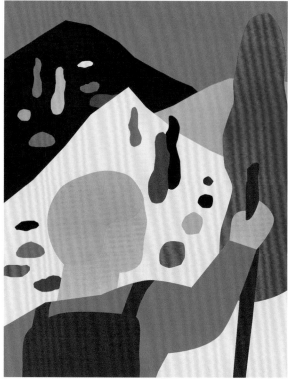

Top left:
Kiss, personal work, 2014, digital, 28 x 22 cm (11 x 9 in).

Above left:
Children's authors, *FOCUS Spezial* magazine, 2015, digital, 16 x 19 cm (6 x 7½ in).

Top right:
Jakobsweg, *FOCUS Spezial* magazine, 2015, digital, 16 x 19 cm (6 x 7½ in).

Above right:
Morning etude, personal work, 2015, digital, 28 x 21 cm (11 x 8 in).

Opposite:
Öntöz [letter 'ö'], book illustration, *Ábécés könyv* by Anna Kövecses, 2013, digital collage, 23 x 15 cm (9 x 6 in).

öntöz

Patrick Kyle

Born: 1987, Toronto
Lives: Toronto

Based in Toronto, amid the thriving Canadian illustration and comics scene, Patrick Kyle fits (or rather fails to fit neatly into) somewhere in that space between art, illustration and comics. He has issued 12 instalments of his *Distance Mover* comic, which has helped him gather a cult following among illustration aficionados and followers of zines. He has also launched his own publishing and printing company, Mother Books.

Comics I'm particularly invested in the comics scene, while also dabbling a little in fine arts. Making comics was a childhood goal of mine that I've stubbornly carried with me into adulthood. The work I'm doing now is a little less influenced by traditional cartooning and a little more influenced by fine art.

My work in illustration and comics definitely compliment each other. I want to make chaotic, strange or challenging work when I am making a comic or a zine, and when I am making an illustration I need to effectively communicate ideas in images. The practices trickle into and bolster each other.

Style In the last year or two it's become less and less important to have a specific style. I feel it's more important to be flexible and willing to try new things. It's better to put yourself out there than to be really strict about what you can and can't do. As an illustrator, I can see how that could be unappealing to some clients. People don't often want surprises: they want something specific and safe.

Low-fi In school figurative or realistic work was really not my strong point, so I started getting more interested in certain printmaking aesthetics and less concerned with making things look polished or real. I like to be spontaneous and fast when I'm making work. I've started to use the computer a bit more to clean things up and for some colour work – but I still use brush and ink on paper for all of my drawings. I do very little preliminary work.

Ideas
I keep a sketchbook and I draw whenever I can. Most of my ideas come spontaneously through the process of drawing.

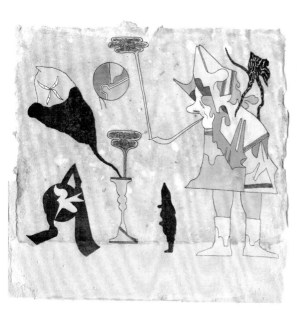

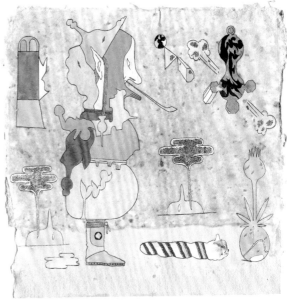

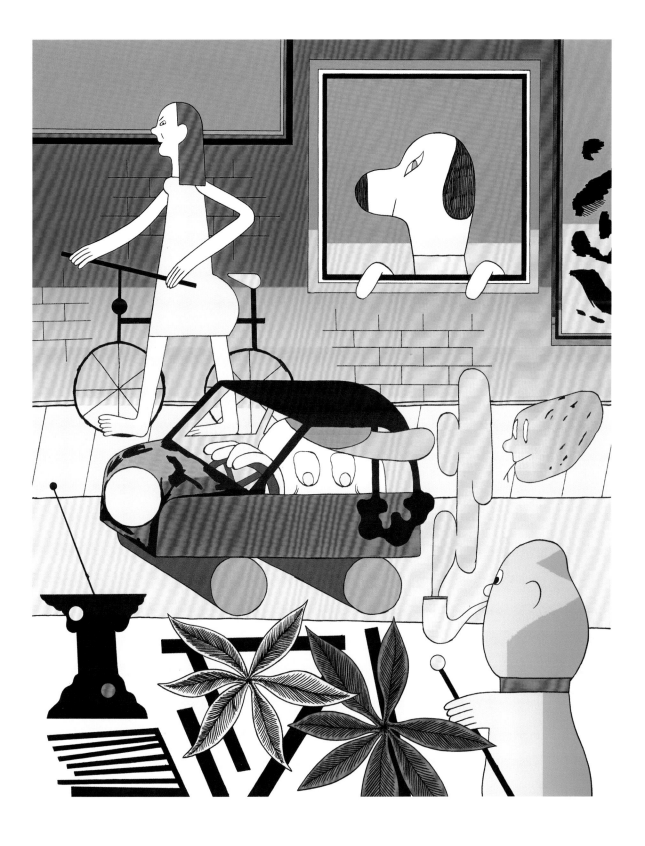

Opposite left:
Ceremonial Pipe-Blow w/ Four Eyed Genie and Gnome Silhouette, created for 'A Blazing Fire' exhibition, Magic Pony, Toronto, 2013, mixed media on paper, 30 x 32 cm (12 x 12½ in).

Opposite right:
Pensive Magician w/ his Possessions and Pet Cat-worm, created for 'A Blazing Fire' exhibition, Magic Pony, Toronto, 2013, mixed media on paper, 30 x 30 cm (12 x 12 in).

Above:
Street Scene, 2013, ink on paper with digital, 30 x 10 cm (11 x 4 in).

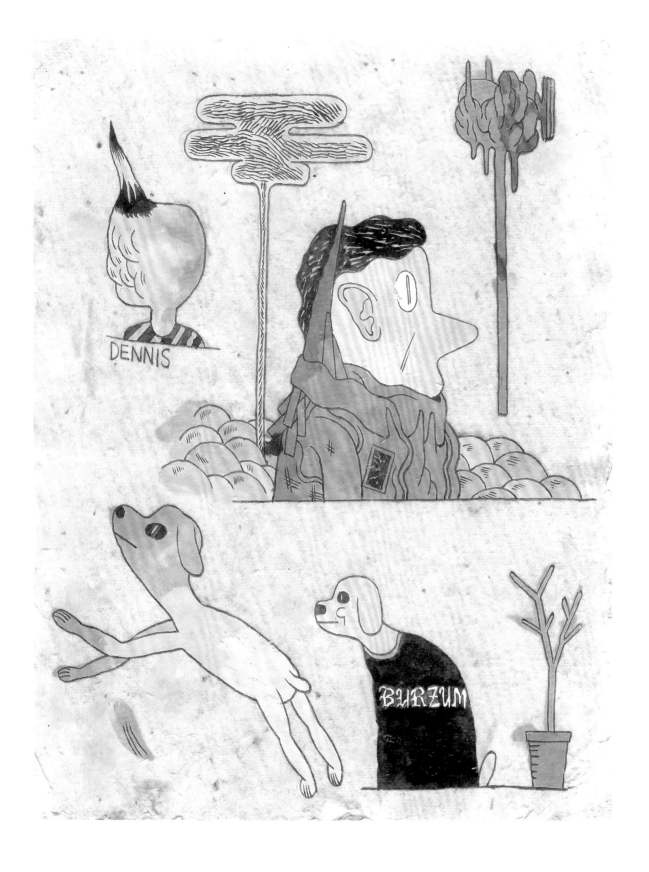

Burzum Retriever, 2012,
mixed media on paper,
24 x 20 cm (10 x 8 in).

Top left:
Intimidating Dog, 2013, mixed media on paper, 19 x 15 cm (7½ x 6 in).

Above left:
Computer Locked, created for *The New York Times*, 2012, mixed media on paper, 25 x 23 cm (10 x 9 in).

Top right:
Seven Seals, 2013, mixed media on paper, 24 x 20 cm (10 x 8 in).

Above right:
Elf w/ Stick, 2013, mixed media on paper, approx. 23 x 25 cm (9 x 10 in).

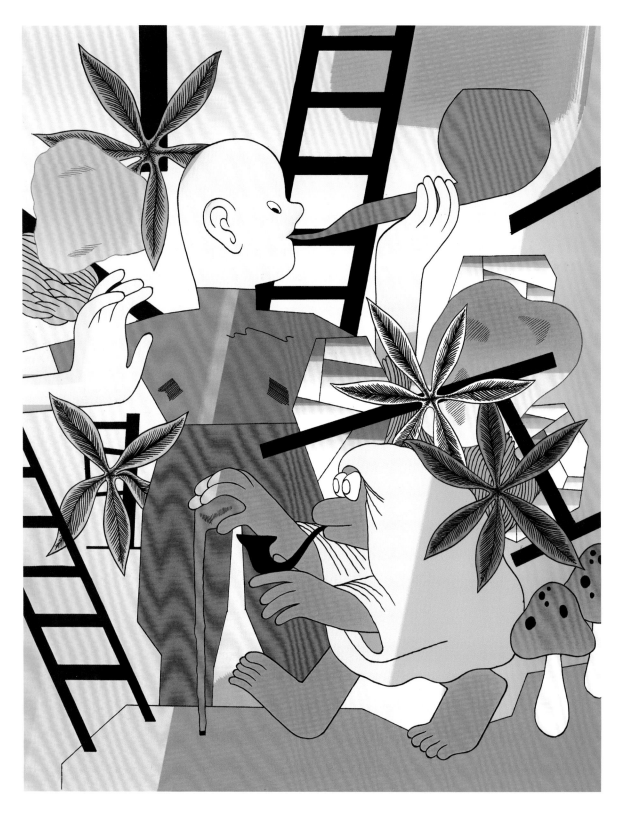

Woods 1, 2013, ink on paper with digital, 36 x 30 cm (14 x 11 in).

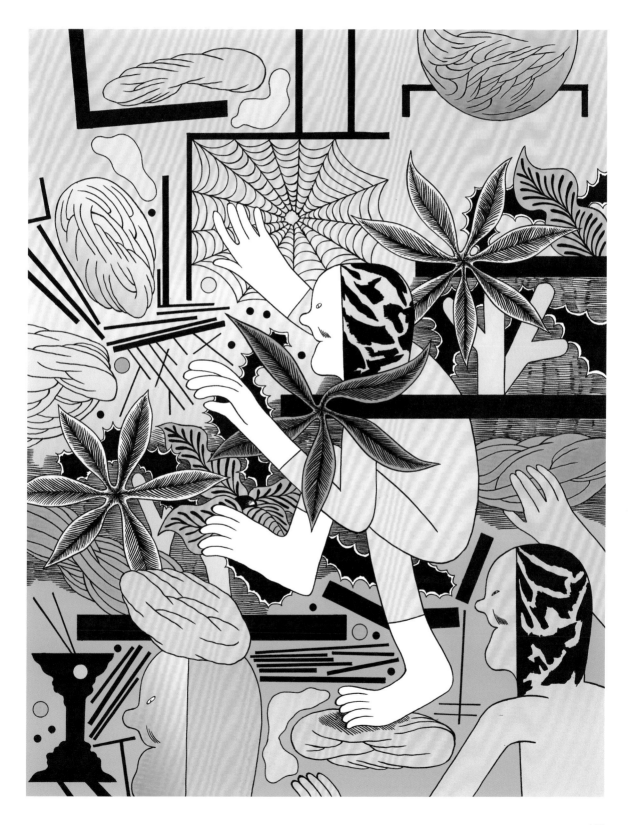

Simon Landrein

Born: 1984, Rennes (France)
Lives: London

Simon Landrein works as an animation director and uses his spare time to work on illustrations. Over the years he has simplified his illustration style such that his pieces resemble comic panels, creating an effect that is both playful and humorous.

Education I attended Supinfocom [École Supérieure d'Informatique de Communication] in Valenciennes in France. On this course, students learn how to produce a 3D animated movie. It's not only about technical skills for animation: you also learn everything about cinematography, lighting, composition and sound design.

Process I begin by sketching on paper, before moving on to do an outline with the computer afterwards. It enables me to be more flexible with the composition and colouring.

Because I don't use words at all in my illustrations, I spend quite a lot of time studying body language, because it allows me to add extra nuances to the characters that I draw.

Below:
Fool's Gold record label flyers for the South by Southwest festival, 2014, digital, 15 x 21 cm (6 x 8 in).

Opposite:
Illustration for 'La Compagnie du Kraft' exhibition, 2014, digital, 70 x 50 cm (27½ x 20 in).

Opposite:
Illustration for 'Black Canyon'
exhibition, 2014, digital, 70 x 50 cm
(27½ x 20 in).

Above:
Couple, for the L'Attrape Rêve
gallery exhibition, 2015, digital,
70 x 50 cm (27½ x 20 in).

Comic for 'Paulette' magazine,
2014, digital, each 30 x 21 cm
(11 x 8½ in).

Miju Lee

Born: 1982, Busan (South Korea)
Lives: Barcelona

The South Korean-born artist Miju Lee studied industrial design at university but had a change of heart about what she wanted to pursue as a career. She moved to Barcelona and joined an illustration course on a whim, and spent time going on walks and people-watching for inspiration. She now refers to this period of her life as 'the beginning of everything I am doing now'.

Process Some people describe my work as naive and childish, but I never intended it to be seen that way. Illustration is just a language I have learned in order to communicate with people in my adoptive land.

I started drawing with coloured pencils, but now I have expanded in the direction of painting, collage and ceramics. I try to respect the character of each material, and find a way to become more comfortable with it. I love working with my hands.

I think illustrators often portray themselves as working without stress, but that isn't true for me. There are definitely moments when I have to finish a project that I have become unenthusiastic about, so I picture myself as a horse that needs a carrot in order to be motivated enough to run.

In essence, my work is about getting the little girl in me to come out and play with my adult mind.

Below left:
Girl with dot t-shirt, 2014, mixed media on canvas, 53 x 46 cm (21 x 18 in).

Below right:
Shy Girl (Chica Vergonsoza), 2014, mixed media on canvas, 53 x 46 cm (21 x 18 in).

Opposite:
Untitled, for *Erase* magazine, 2013, coloured pencil on cardboard, 29 x 22 cm (11 x 9 in).

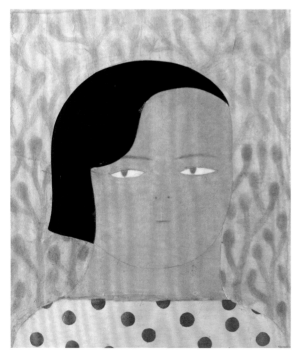

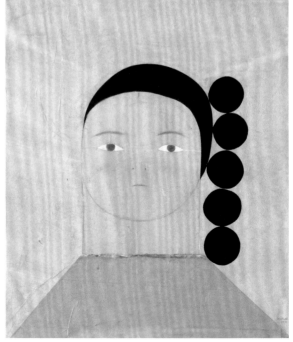

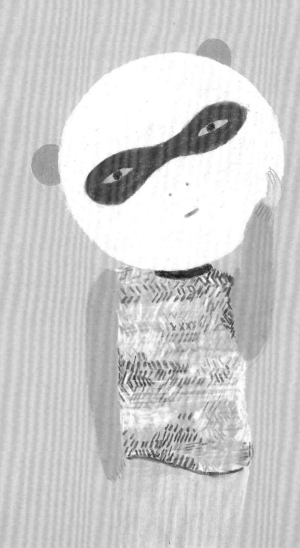

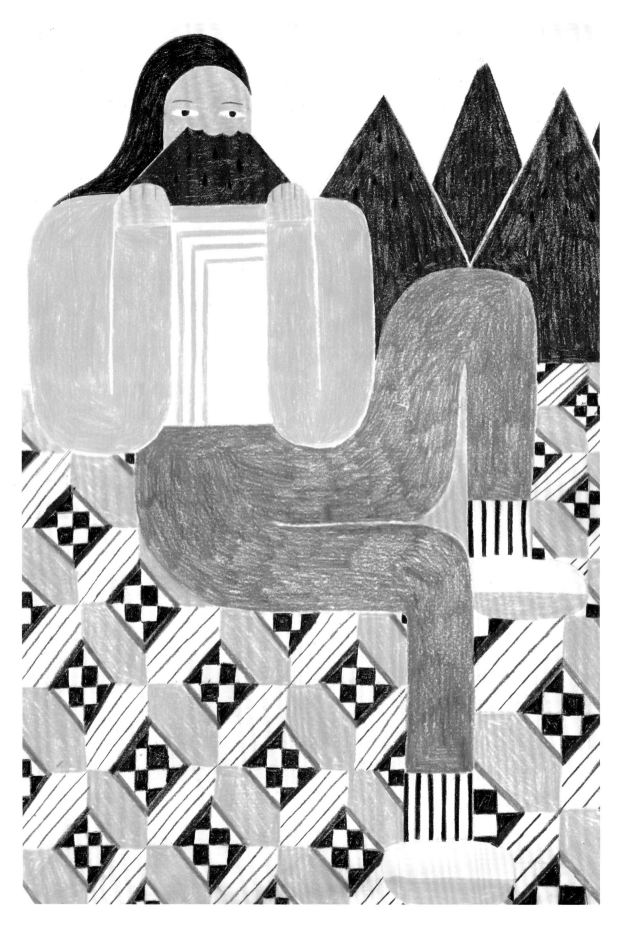

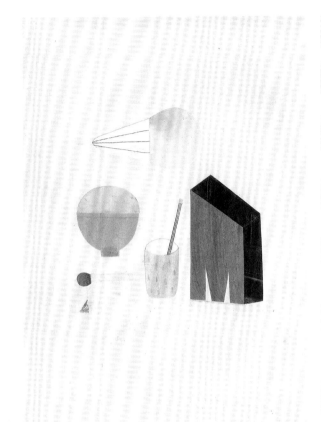

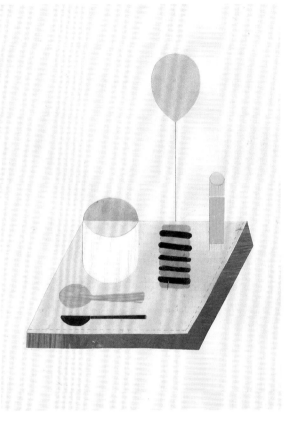

Opposite:
Water melon mountains (Montañas de sandía), 2014, coloured pencil on paper, 40 x 30 cm (16 x 12 in).

Above left:
Object Serie 04, 2012, collage, 18 x 15 cm (7 x 6 in).

Above right:
Object Serie 03, 2012, collage, 18 x 15 cm (7 x 6 in).

Maria Luque

Born: 1983, Rosario (Argentina)
Lives: Rosario

Maria Luque is quick to say that she is 'not a very good illustrator', but her body of work proves her wrong. Through her deceptively simple forms and bright colours, she brings a sense of the bizarre to the domestic scenes that she portrays in her drawings. Featuring things like lions sprawled across the floors of ornate living rooms, her works are meant to 'make people laugh and think at the same time'.

Materials The materials I use most often are coloured pencils, markers, watercolours and acrylics. I use a lot of different materials, but I always use paper. You'll also notice that I use a lot of red and yellow in my practice. I do this on purpose to emphasize the strangeness of the scenes I draw.

Process When I draw, it is almost as though my hand is possessed and moving by itself. I don't think at all. I'm also always on the lookout for things that have happened to my friends, or situations I spot on the street. I combine these, even if they don't make any sense, into a scene that I can then depict in my work.

I've done very few commissioned works because I really struggle to achieve something when I have to follow a brief. That's why I prefer to call my drawings just drawings rather than illustrations.

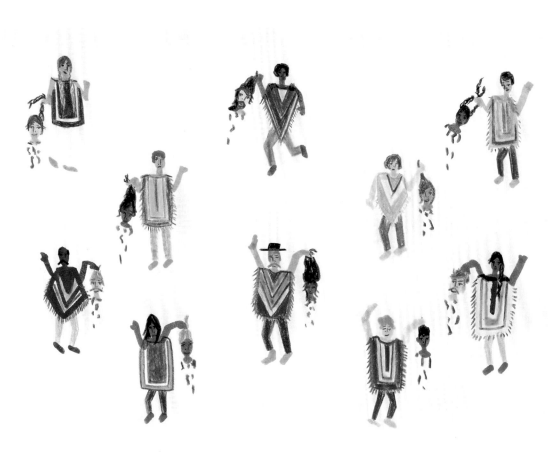

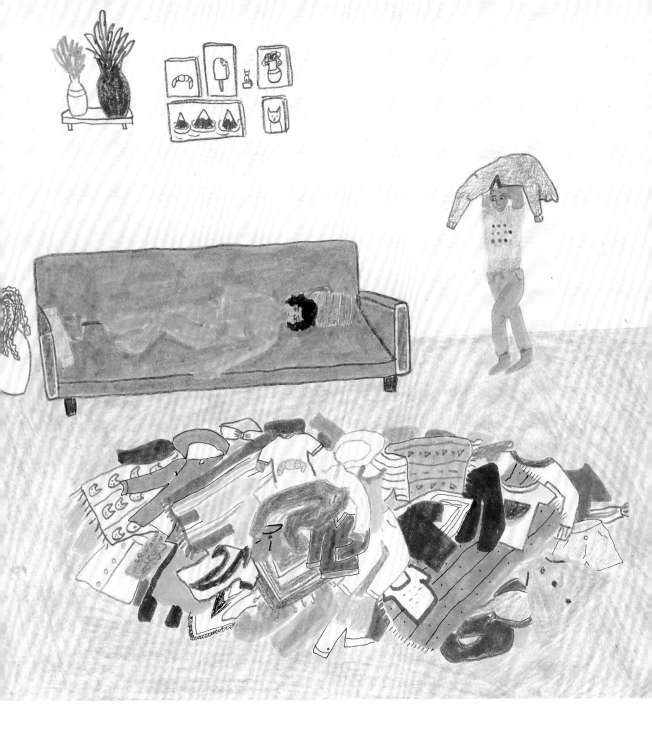

Opposite:
Trophies, 2013, coloured pencil
and marker on paper,
20 x 25 cm (8 x 10 in).

Above:
*Let's make a mountain with all our
clothes*, 2012, coloured pencil
and marker on paper,
20 x 30 cm (8 x 12 in).

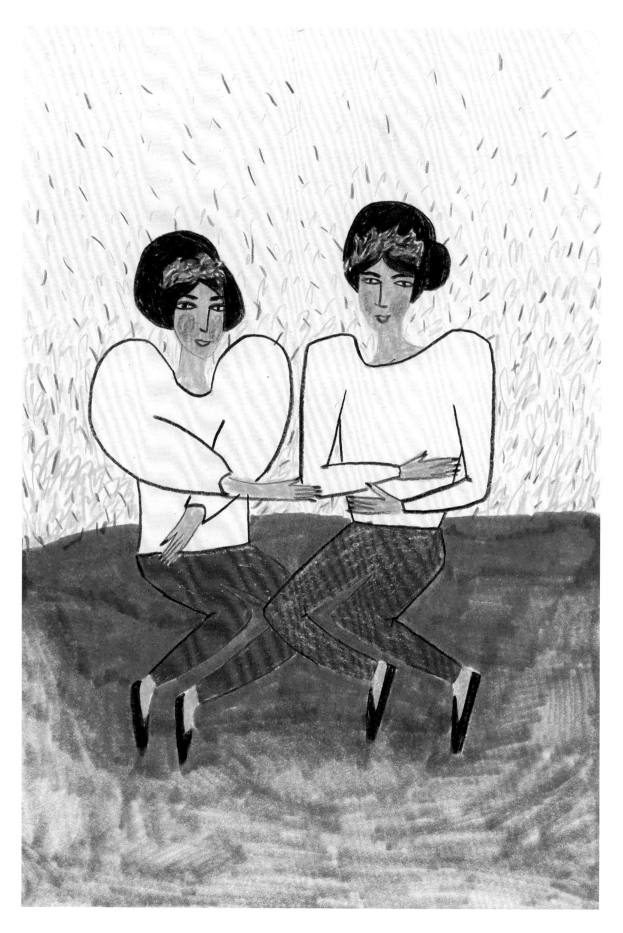

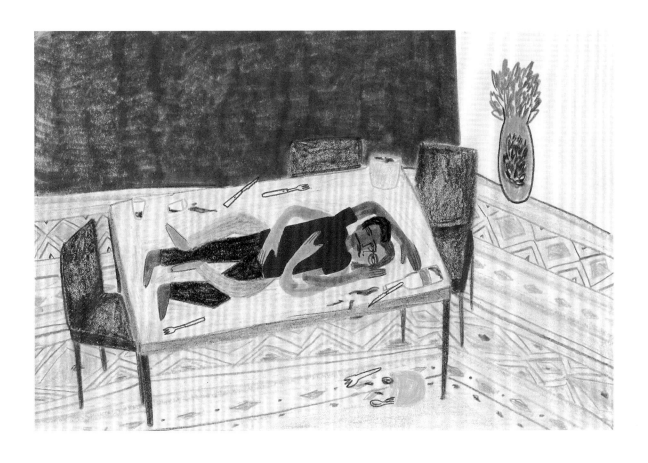

Opposite:
It's not going to rain, 2013, coloured
pencil and marker on paper,
21 x 14 cm (8 x 5½ in).

Above:
Food is not ready yet, 2013,
coloured pencil and marker
on paper, 15 x 22 cm (6 x 9 in).

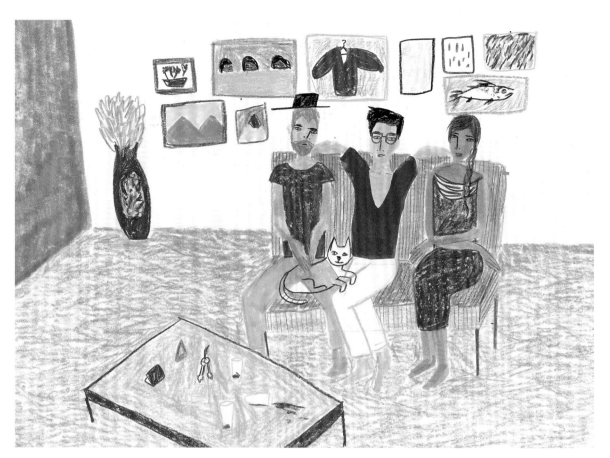

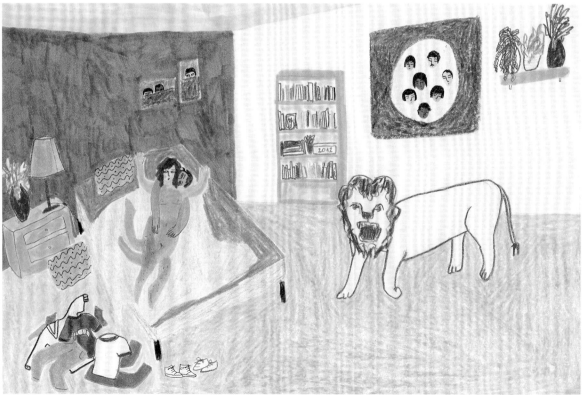

Top:
We wait for you, 2013,
coloured pencil and marker on
paper, 15 x 21 cm (6 x 8 in).

Above:
There's a lion in your house, 2012,
coloured pencil and marker
on paper, 14 x 20 cm (5½ x 8 in).

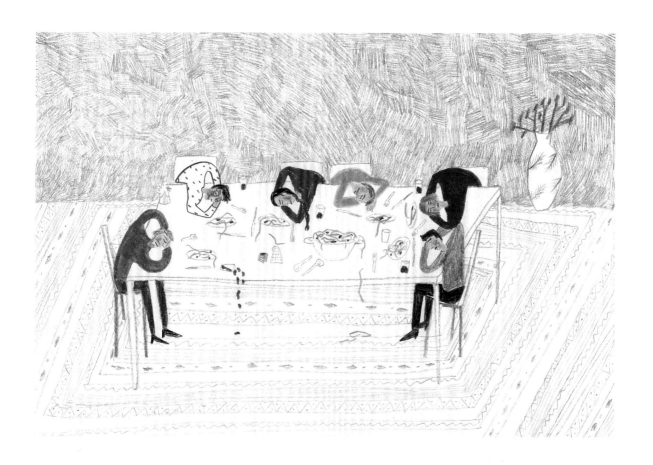

Top:
Spaghetti, 2014, coloured pencil
and marker on paper,
15 x 21 cm (6 x 8 in).

Above:
Afternoon nap, 2013,
coloured pencil and marker
on paper, 15 x 21 cm (6 x 8 in).

Clara Markman

Born: 1987, Paris
Lives: Lyon

Filled with bright colours and sinuous forms, Clara Markman's illustrations take everyday situations and add a dash of the absurd. She trawls through second-hand bookshops and garage sales for inspiration, and is particularly drawn to the aesthetic of Eastern European children's books from the sixties.

Process I like quill and Indian ink, but I like pure colours as well. I'd say that a large part of my work is about picking out the right colours and using them together.

For my master's degree dissertation, I wrote about how some ideas can be expressed only with and while drawing. I questioned the form of intelligence specific to drawing. It was based on the practice of three illustrators: Saul Steinberg, Tomi Ungerer and Quino. I read about their work and tried to analyse their styles in order to learn more about how our imagination works. I still bear these questions in mind when I'm drawing today.

Bookshops I love going to libraries and bookshops to gather inspiration. Some of my favourites are the Quai des Brumes in Strasbourg, and the Halle Saint Pierre museum bookshop in Paris, which specializes in *art brut* ('raw art'). The latter is not big, but ... what a collection! Le Monte en l'Air is, for me, one of the best bookshops in Paris. They have a fine selection of children's books, and an amazing fanzines collection that cannot be found anywhere else.

Art versus illustration I used to see a clear difference between the two, but the more I think about it, the less I see it. Illustration is obviously less considered, less exhibited, less studied. It's a shame and a good thing at the same time. Anyway, this seems to be changing – look at David Shrigley, for example!

Below:
Untitled, from 'The Castles' project, 2014, Indian ink, inks and watercolour, 32 x 45 cm (12½ x 18 in).

Opposite:
Untitled, research page, 2012, Indian ink, inks and gouache, 31 x 24 cm (12 x 9½ in).

œuf à oreilles

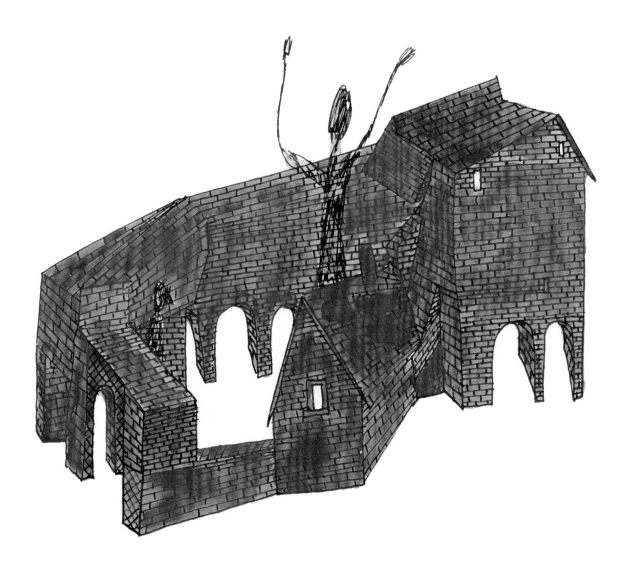

Untitled, 2014, Indian ink and watercolour, 14 x 16 cm (5½ x 6 in).

Untitled, 2012, Indian ink and inks,
21 x 24 cm (8 x 9½ in).

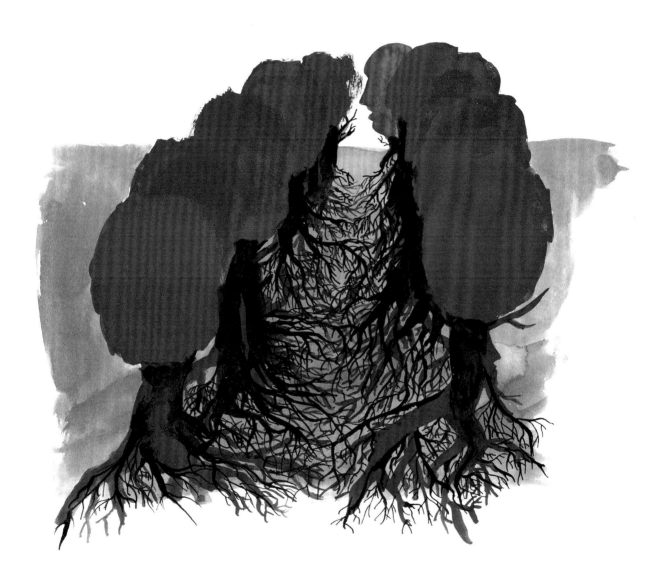

Vânia Mignone

Born: 1967, Campinas (Brazil)
Lives: Campinas

Vânia Mignone grew up with eclectic interests such as dance, cinema and music, and never intended to become an artist. It was only after she discovered wood engraving at art school that she decided to use it as a platform to showcase her varied influences. Her work is both unruly and playful, and draws on a colourful hodge-podge of different media, such as comics, advertising, billboards, poetry, photography, graffiti, wood engraving, theatre and the circus.

Style My drawings are simple in both design and form. I use primary colours with little tonal variation, and capital letters to caption the works. I use wood or paper as a support because I never wanted to make paintings on canvas. I like to think that my works are more like signposts. I like the mystery created by the relationships between these fragmented pieces (man, woman, red, chair, road, word) when they are put together.

Materials My standard materials are acrylic, paper and wood. I do not use the computer, camera or live models directly in my work. All of it comes from memory. Over the years, I have also developed a unique technique that involves wood engraving, drawing, collage and painting all in the same work. I never plan what I will do in advance. Perhaps because of my need for instant and easy communication, I use a lot of red, yellow, black and white. Most of the time the variations are restricted to the details.

Art versus illustration Illustration makes an idea visible through reason, aesthetics and intelligence. Art, on the other hand, makes visible what the artist himself/herself doesn't know.

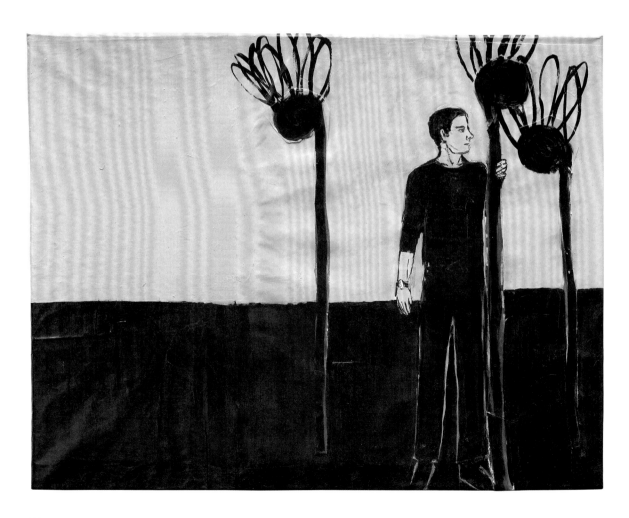

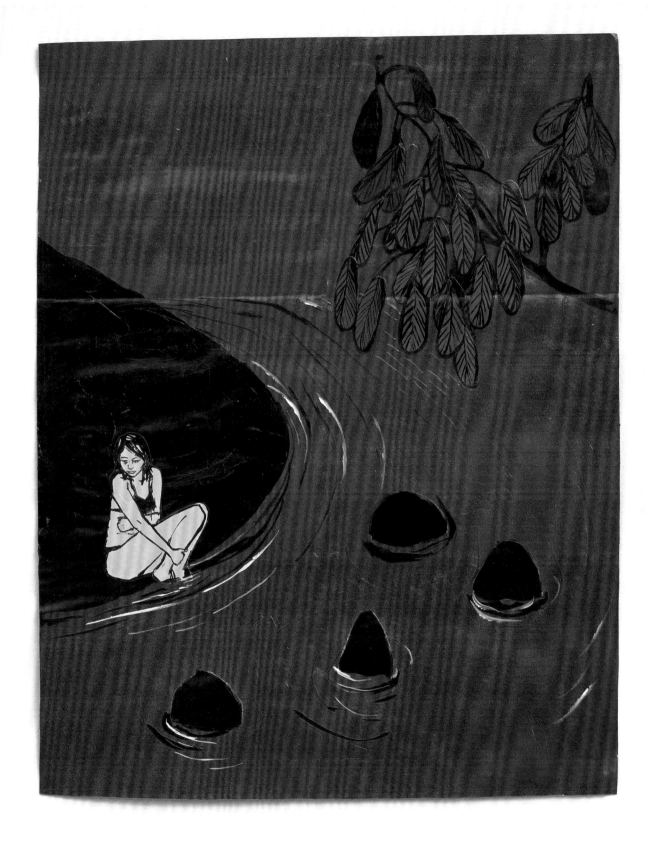

Opposite:
Untitled, 2008, collage and acrylic
on paper, 33 x 43 cm (13 x 16 in).

Above:
Untitled, 2011, collage and acrylic on
paper, 70 x 57 cm (27½ x 22½ in).

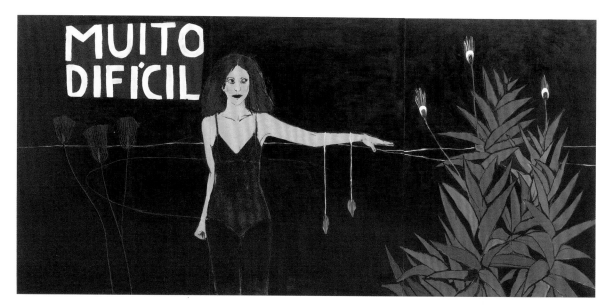

Top:
Untitled, 2011, acrylic on MDF,
140 x 300 cm (55 x 118 in).

Above:
Untitled, 2015, mixed media on
wood, 140 x 200 cm (55 x 79 in).

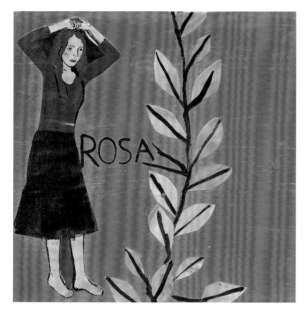

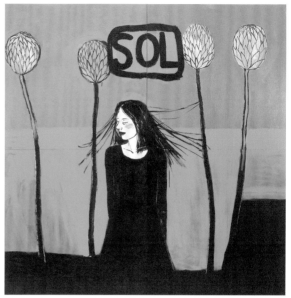

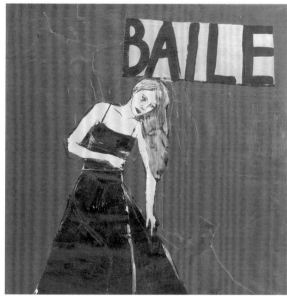

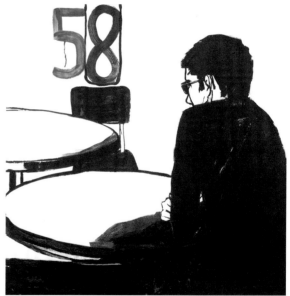

Top left:
Untitled, 2008, collage and acrylic on paper, 29 x 28 cm (11½ x 11 in).

Above left:
Untitled, 2008, collage and acrylic on paper, 29 x 28 cm (11½ x 11 in).

Top right:
Untitled, 2010, acrylic on MDF, 180 x 180 cm (71 x 71 in).

Above right:
Untitled, 2010, acrylic on MDF, 90 x 90 cm (35½ x 35½ in).

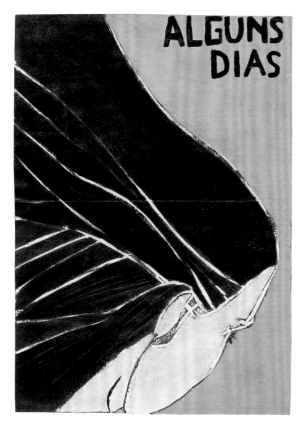

Untitled, 2015, mixed media
on paper, 51.5 x 52.5 x 4 cm
(20 x 9 x 1½ in).

Virginie Morgand

Born: 1986, Lyon (France)
Lives: Paris

When Virginie Morgand first arrived in Paris, she started working in animation studios, where she helped to produce short films and television shows for children. Her experiences with character design, scenery development and storyboard creation inspired her later on to create paper illustrations away from the constraints of graphics animation. After attending L'Atelier Dupont in Paris, she picked up screen-printing and it has been her method of choice ever since.

Process I do not spend too much time on a drawing or it becomes too smooth. I try to think like a child when selecting the palette for my works. For instance, the skin of a character can be blue or red – my goal is not to model reality, but to interpret it in my own way, in the moment and with my mood. There is virtually no concept of decoration or light.

I do not like what is too clean. I can't work with vector shapes and perfect lines. I like rough textures and imperfection, and I try as much as possible to stick with these preferences. When I screen-print my work, I test it first on rough paper that's lying around. Sometimes I scan some sheets of paper and then integrate their defects to create charming illustrations. I particularly love the old techniques of hand-printing using linocut, screen-printing and stencil buffers. They allow me to experiment with the layering of shapes using very pigmented inks.

Trends I think I belong to a 'family' of illustrators aligned with mid-century art, somewhere between graphic design and illustration.

Below left:
Chat Perché, poster, 2014, three-colour screen print on paper, 65 x 50 cm (25½ x 20 in).

Below right:
Festival de Martigues, poster, 2014, three-colour screen print on paper, 176 x 120 cm (69 x 47 in).

Opposite:
La Piscine #2, 'La Piscine' series, exhibited at Slow Galerie (Paris) and Ó! Galeria (Porto), 2015, three-colour screen print on paper, 70 x 50 cm (27½ x 20 in).

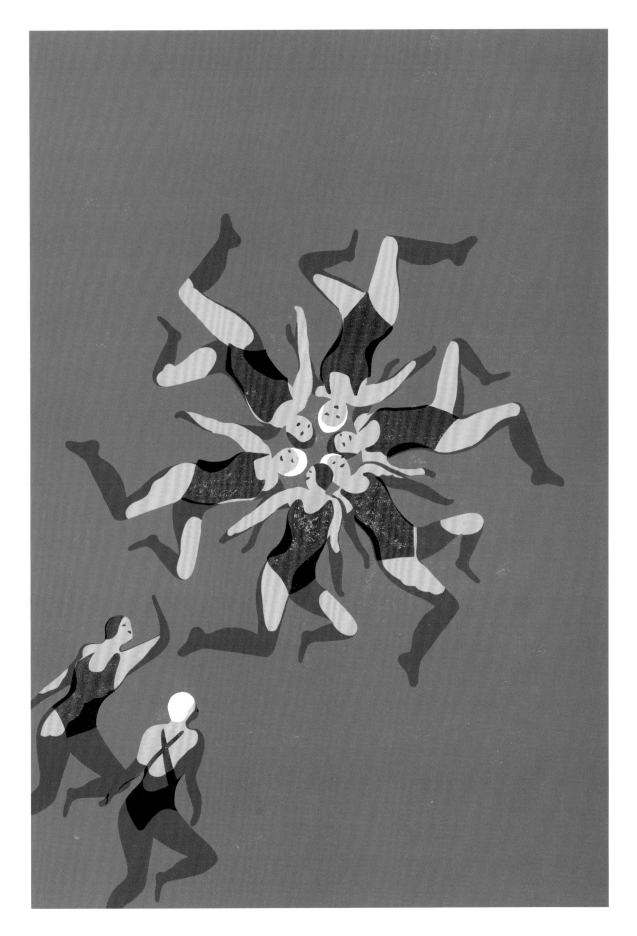

Opposite:
Crowd #01 – Beach, poster, 2014,
three-colour screen print on paper,
50 x 65 (20 x 25½ in).

Above:
Kabaret, 2014, three-colour
screen print on paper,
40 x 30 cm (16 x 12 in).

Robert Nicol

Born: 1980, UK
Lives: Norfolk (UK)

Filled with black humour and a riotous disorder that recalls the work of Hieronymus Bosch, Robert Nicol's miniature paintings and ceramics are deliberately bereft of narrative, allowing viewers to speculate endlessly on the bizarre scenes depicted. Nicol says that his practice revolves around 'sexuality, ritual, the existential struggle between the absurd and the surreal, and the presentation of a world that is a parody of our own'.

Artlessness While the term 'childlike' is often bandied about pejoratively, I see it as a direct link to many positive things, including discovery, honesty, openness and directness. I am not sure if my main aim is to unsettle; what I would be content with, in this increasingly sophisticated and complex world, is for people to look at my art and reassess their life in relation to these images. Maybe people do lack, as life evolves, raw experiences, and I want to be able to evoke the latter through my work.

Process The materials I use regularly are acrylics, watercolour, coloured pencils and ceramics. My relationship with computer work has developed over time – in my work as an illustrator I scan and alter images and often add digital textures, as well as make purely digital images for print projects. Pastel colours are also dominant in my work because I enjoy the process of colour mixing and matching. I work very quickly because I am a very impatient person: it takes me about two days to make each painting or drawing, while the ceramics take longer because of the firing and glazing process.

I don't tend to discard much of what I do, even if they're 'rudimentary' sketches – I am more methodical than the image of the artist burning and binning work. I think most images you make have value; it just takes a little bit more time to find the good in some.

Influences I have a range of reference points: these include naive and outsider art, design works from the Festival of Britain era, Thomas Bewick, graphic novels, landscape paintings and etchings by the Dutch Masters, Staffordshire pottery and Murano glass.

I am also a lecturer at Camberwell and Central St Martins [in London], and have learned a lot from my students and their approach to art and design. Being an artist can make you feel jaded sometimes, and their enthusiasm reminds me of my love for the process of image-making.

Smilie, 2013,
acrylic on Perspex,
30 x 42 cm
(12 x 16½ in).

Above:
Cave, 2013, acrylic on Perspex,
25 x 28 cm (10 x 11 in).

Overleaf:
Untitled, 2014, acrylic on Perspex,
42 x 59 cm (16½ x 23 in).

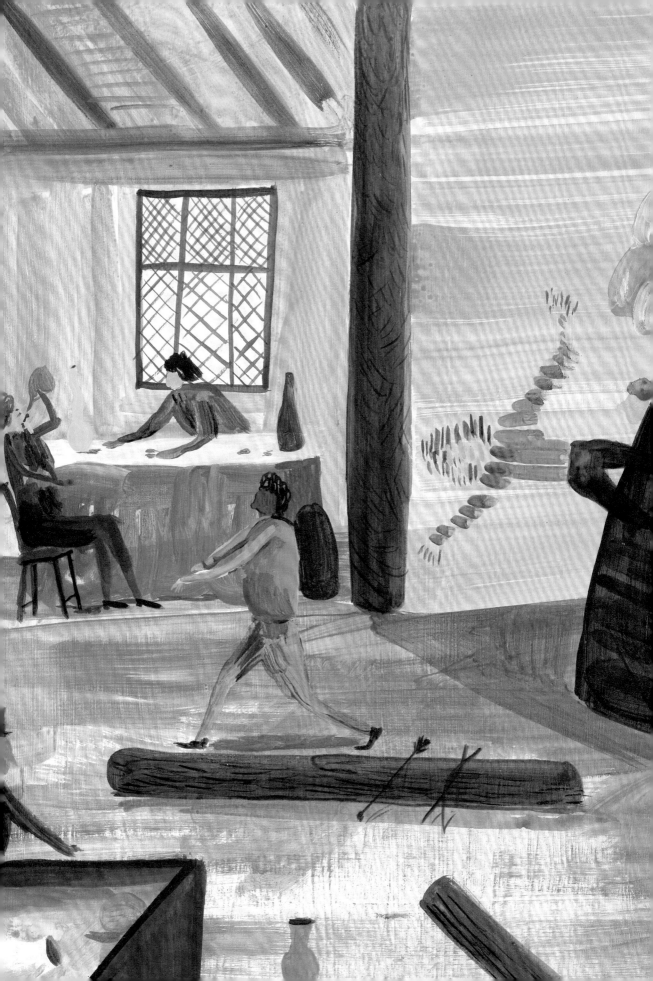

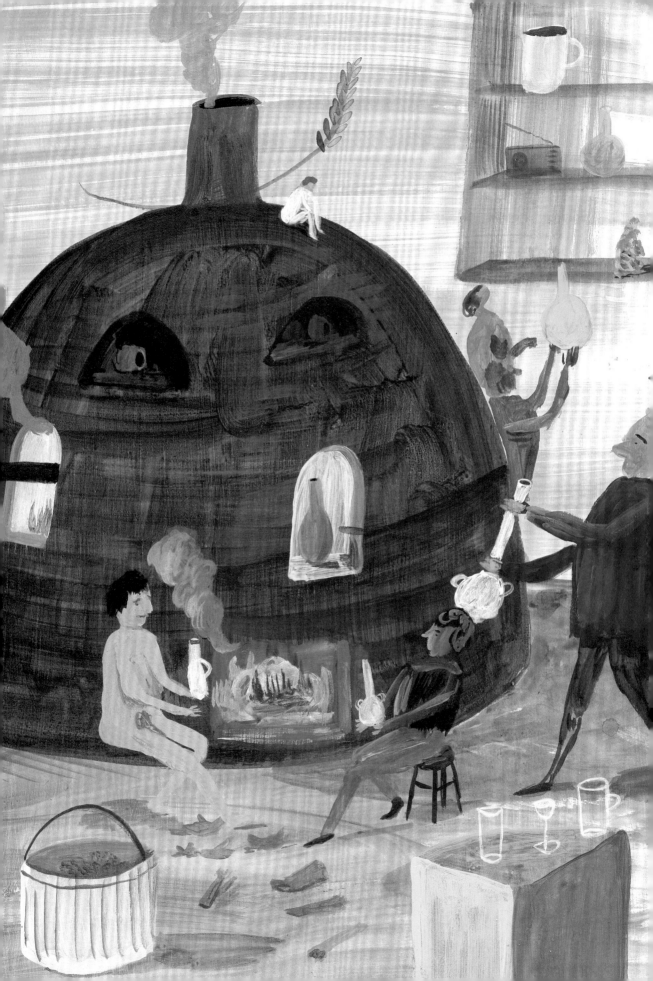

The Hut, 2013, watercolour on
paper, 30 x 42 cm (12 x 16½ in).

Untitled, 2011, watercolour on
paper, 30 x 42 cm (12 x 16½ in).

Malin Gabriella Nordin

Born: 1988, Stockholm
Lives: Stockholm

Like a roving animal, attuned to the rhythms of nature (a mineral rich Nordic landscape, obviously), to the changes of colour, light and texture in its environment, Malin Gabriella Nordin's work travels constantly through mediums (collage, painting, sculpture, ceramic) and supports (paper, canvas, wood, found objects, stretched cloth) in search of the right support, the right balance, the ideal (and idealized) resting place for a sensation or a perception. She has described her creative process as 'a game of dominoes' and this element of playfulness is integral to the work, which will often take a surprisingly sober and serious, often lyrical, turn.

Style I've always worked in a very direct and intuitive way. I try not to get stuck on how a specific line or shape should take its form. I let my hands guide me instead of my head. I allow my hands to feel the lines, and let my eyes accompany the gestures.

Process The quality of the materials I use is very important to me, as is finding the right technique for each piece. I think about the texture, size and material, and the relationship between them. Something that works as a sculpture may not be a good painting; a certain quality gets lost in the process of translating it.

During the working process, the subject within the original frame changes. I need to be observant, ready to rethink and have the ability to see the deviations from the anticipated. Just like in a game of dominoes, the next step always depends on the one before. The process continues infinitely as leftover pieces from one project can become a major part of the next.

Day/night I'm constantly trying to change my perspective on the world, seeing everyday objects as being different and abstract. I cut out colours and textures in different shapes to reconstruct them in other ways. At night, I see things differently. Objects become shadows and shapes that constantly surround me. They merge to make up the key elements in my work.

I try to translate what I see at night into my days, making the invisible visible, staying on the threshold between day and night. It's about being open to the unknown and accepting it. Instead of asking why and how and analysing everything to its core, I think there is beauty in the unknown, and being seduced without a fight. I believe that not knowing everything leaves space for our imaginations to come to life.

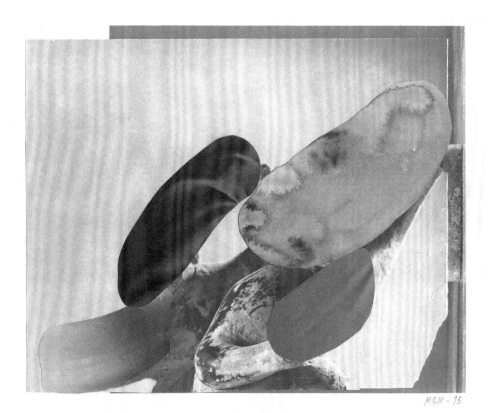

Left:
Untitled, 2015, collage and ink on paper, 23 x 28 cm (9 x 11 in).

Opposite:
Untitled, 2015, collage and ink on paper, 29 x 20 cm (11½ x 8 in).

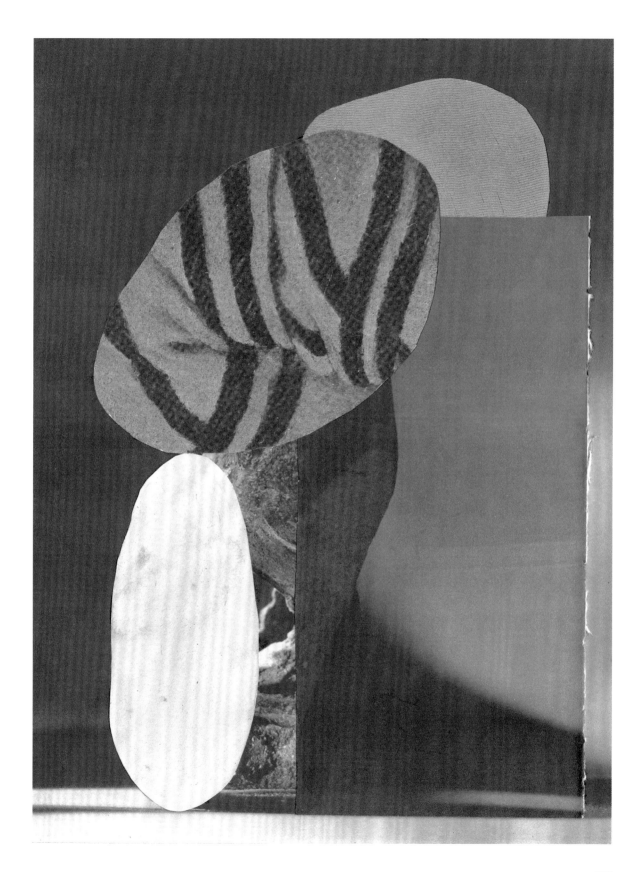

Above:
From my studio, 2014.

Opposite:
S som I Sol, 2014, acrylic on silk,
150 x 110cm (59 x 43 in).

Marcus Oakley

Born: 1973, Norwich (UK)
Lives: Edinburgh

In the background you may detect echoes of his childhood in Acle, a village in Norfolk (elements of the countryside, animals, the open air) and the influence of British Pop Art (Caufield, Hockney) whereas the foreground is made up of dizzying compositions, startling colour combinations, and a sense of irreverence. These combine to form an aesthetic sensibility that is far more refined and carefully crafted than may at first appear, and which travels freely between the commercial and the personal.

Background Growing up in Acle, a little village in Norfolk, I just wanted to be outside doing something, making something. I like to think that the landscape of Norfolk is one giant piece of folk art, as most of the county is arable land. Seen from above, the fields look like a huge patchwork quilt made up of tones of green and oat-like colours. I still feel a connection to my younger creative self. I'm still intrigued and puzzled by the world – and through drawing I can attempt to understand.

I graduated from Camberwell College of Arts with a degree in fine art and graphic design. We didn't really use computers that much in the early 1990s, and much of the course was analogue. I often used Xerography and Omnicrom, and dabbled in silk-screening. Even when I made video art, I liked the clunky analogue-ness of the old video equipment.

Process I use anything I can get my hands on. I also discard a lot of my work. It feels good to throw things away. Currently, my work is simply about the line and the possibilities of linear forms. Thick lines, thin lines, zigzagged, curved, straight, fast, slow, wonky, abstract and pictorial: they all have their own special moods and melodies. I'm continuously learning how a line has the potential to be anything, and can be interpreted into anything 2D, 3D, or even sonically.

I also make rubbish music.

Art versus illustration There is a fuzzy, foggy overlap. Illustration fits in snugly between art and design, and can flop around wherever it wants.

Inspiration I love the work made by people from hundreds and thousands of years ago, by many cultures from all over the world; particular favourites are Greek Cycladic art, Japanese Dogu figures and totem poles by the First Nations people of the Pacific Northwest Coast. I like the craft and honesty of these objects.

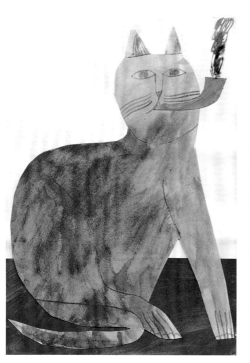

Far left:
Smoking Cat, 2013, pencil, ink and acrylic on paper, 30 x 21 cm (12 x 8 in).

Left:
Dogs in the Park, 2013, pencil, ink and acrylic on paper, 30 x 21 cm (12 x 8 in).

Opposite:
Hayleys Pots, 2013, pencil, ink and acrylic on paper, 30 x 21 cm (12 x 8 in).

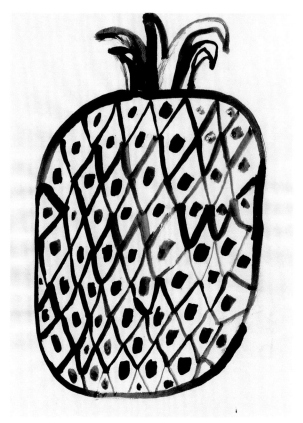

Top left:
Colour Spiral, 2013,
pencil, ink and acrylic
on paper, 30 x 21 cm
(12 x 8 in).

Above left:
Stacked Up, 2012,
ink on paper,
30 x 21 cm (12 x 8 in).

Top right:
Pineapple, 2012,
ink on paper,
30 x 21 cm (12 x 8 in).

Above right:
Colour Stack, 2012,
pencil, ink and acrylic
on paper, 30 x 21 cm
(12 x 8 in).

Opposite:
Very Bendy Man,
2013, pencil, ink and
acrylic on paper,
30 x 21 cm (12 x 8 in).

Adrien Parlange

Born: 1983, Riom (France)
Lives: Strasbourg

Adrien Parlange started working as an illustrator in 2009. He attributes his unfettered style to a 'growing lack of interest in unnecessary decoration'. Preferring the freedom to reinvent and experiment with new techniques every time he starts a project, he believes that he cannot tell stories properly if forced to stick to one style.

Artlessness I wouldn't say that I attempt to unsettle the viewer, but I definitely ask them to fill in the blanks. I use simple geometrical shapes as much as I can to evoke spaces or situations. I let some things remain ambiguous: time, place, age and look of characters. Specifications tend to turn ideas into mere anecdotes.

Technique While I used to draw a lot more, nowadays I prefer cutting coloured paper into different shapes. It's almost like carving. I add or remove bits; I twist, stretch or flatten the shapes until they look right – balanced and elegant. Working with a computer makes many things easier, especially colour testing, but it also makes me lose a sense of scale. At some point I always need to see the actual illustration on paper.

I sometimes stencil my drawings to get rough outlines, stains and accidents, and this counterbalances my tendency to over-control. When I'm stencilling, there is no trace of the gesture of my hand. In a way, the artist is removed entirely from the picture and I am the very first viewer.

Process I start by sketching on the smallest notebook I can find. This is the most exciting part of my work – it feels like I'm plotting against someone. As soon as I get an idea that seems right, I start drawing on a computer. This is where I get slow and meticulous.

Inspiration The way people interact with one another or avoid one another, especially in public spaces, fascinates me. I'll never get bored of drawing bodies in space.

Below:
Illustration for *Humanitas* magazine, 2014, stencils, 15 x 21 cm (6 x 8 in).

Opposite:
Card design for *Humanitas* magazine, 2013, stencils, 15 x 10 cm (6 x 4 in).

Above:
Card designs for *Humanitas*
magazine, 2013, stencils,
each 15 x 10 cm (6 x 4 in).

Opposite:
Illustration for *Humanitas*
magazine, 2014, stencils,
30 x 21 cm (12 x 8 in).

Jeremy Piningre

Born: 1984, Paris
Lives: Paris

Jeremy Piningre started out with comics before his practice developed to reflect a more painterly style of graphic design. He believes his work to be a manifestation of his philosophy of 'life as a broken mirror, with the fragments scattered all around. Through illustration, I relentlessly put these fragments back together.'

Education I studied at the [École Supérieure des] Arts Décoratifs in Strasbourg. It gave me a lot of friends, sausages, and it taught me to demand a lot of myself.

Process Even if I use other techniques, I still think primarily as an artist who draws. Most of the time I only use a 0.18 mm Rotring with Indian ink. Even to make paintbrush traces, I draw them with my beloved pencil. I work almost exclusively in black and white. It's raw, simple, hard and without compromise.
 I sit like Rodin's *Le Penseur* [*Thinker*]; I think like he does, and when I am really sure of what I have to draw, I start. Normally I fail at the start, but after that first crap drawing it is OK.

Inspiration My main subject lies somewhere between the mass production of images and what we can do with that. I am also inspired by the emotional lyrics and stories of nightcore music, and the funny, depressed writings of Romain Gary.

Below:
Séquelles Ennemies, 2014, ink on paper, 16 x 22 cm (6 x 8½ in).

Opposite:
numéro d'art (3), 2013, ink on paper, 80 x 65 cm (31½ x 25½ in).

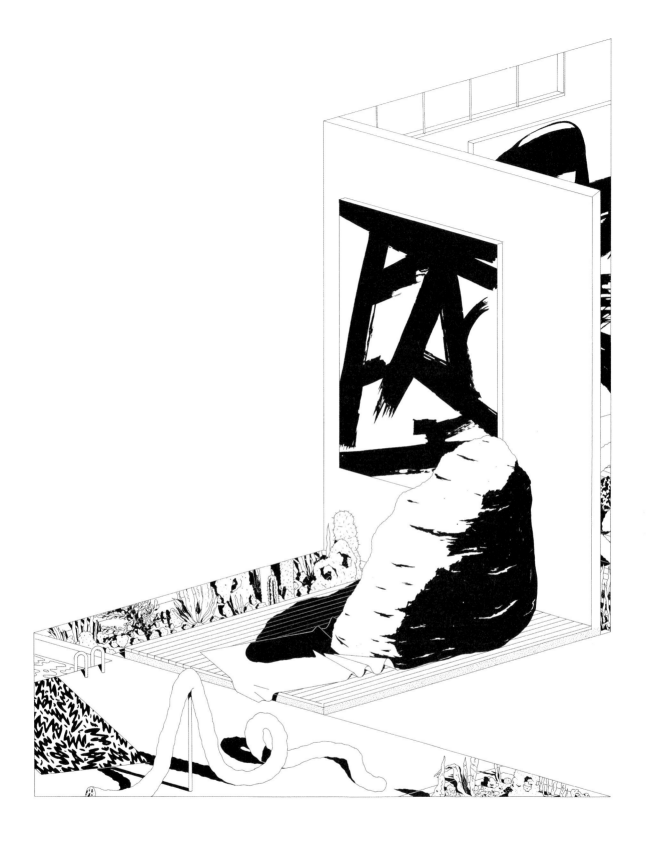

Untitled (mojito), 2012, ink on paper,
30 x 21 cm (12 x 8 in).

Top:
Ceci n'est pas un Matisse, 2015,
computer drawing.

Above:
*Les cimes immuables n'empêchent pas
la putréfaction* (detail), 2012, ink on paper.

Federica Del Proposto

Born: 1978, Rome
Lives: Paris

Describing herself as 'an autodidact who has never attended art school', Federica Del Proposto declares that she loves her career and remains the 'daydreaming child' she always was. She describes her work as sitting somewhere between comics and pure, conceptual illustration.

Background Drawing was my favourite game as a child. I even drew my own toys, as it was the simplest way to have everything I could: if I wanted something I just had to draw it. I started doing what I'm doing now during my childhood – it just took me a few decades to refine it.

I struggled with seeing illustration as anything other than my passion – it felt weird to think that it could also be a commercial route. Besides, I didn't want to go to art school because at that time I was a very rebellious teenager and classic Italian art schools were too old-fashioned for the younger me.

I chose to study architecture at university. My training has given me a particular approach to art: I am very precise, I like clean images and I draw with care and accuracy. I've slowly become softer and more instinctive, but I've always retained my love for clean lines.

Materials I use pencils and fine liners. The role of pencils is often to accompany the fine liners: I use them especially for backgrounds, or to colour large areas.

I wanted to wait until I was more experienced before using lots of colours. The first colour I used in my practice was orange. After an orange–greytones phase I had a long phase of primary colours. Now I'm experimenting with new tones like light pink, brown and green. I've also realized that there is one colour that I always use: light ochre yellow, instead of pure yellow.

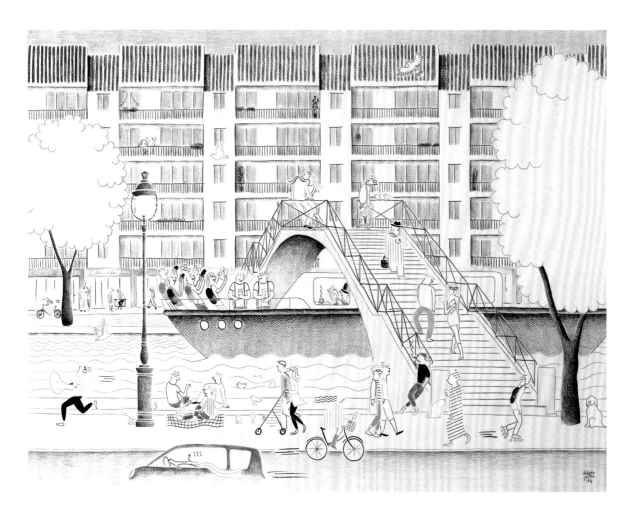

Opposite:
Le Canal, illustrated plan of the shops of Paris's 10th arrondissement, 2014, coloured pencil and fine liner on paper, 50 x 63 cm (20 x 25 in).

Above:
Time to be happy – Playground, Wysokie Obcasy Extra magazine, 2014, coloured pencil and fine liner on paper, 30 x 21 cm (12 x 8 in).

Farrow & Ball, Elle magazine (Paris), 2015, coloured pencil and fine liner on paper, 15 x 20 cm (6 x 8 in).

Alessi, *Elle* magazine (Paris), 2015,
coloured pencil and fine liner
on paper, 17 x 19 cm (7 x 7½ in).

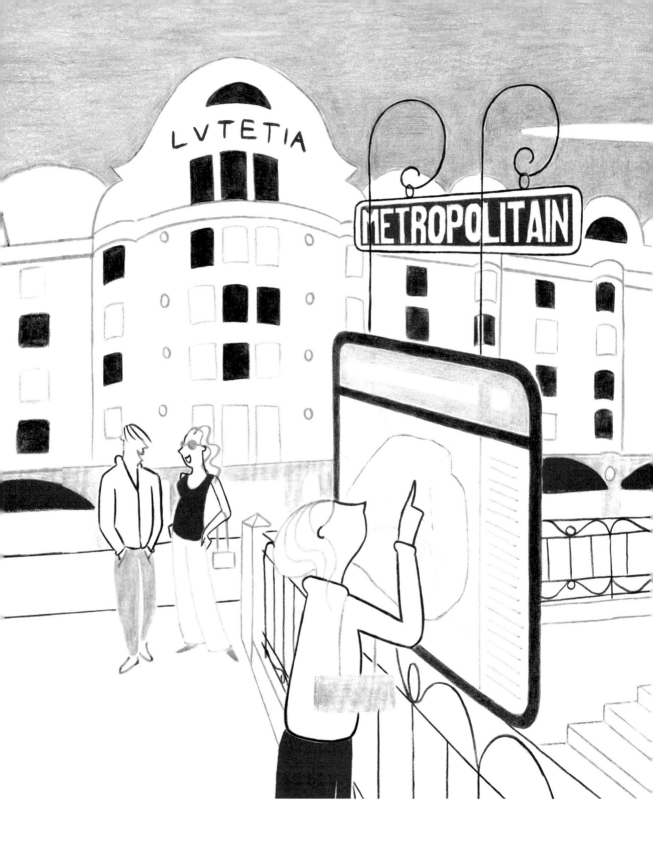

Autour du 7ème arrondissement,
Elle magazine (Paris), 2015,
coloured pencil and fine liner
on paper, 12 x 21 cm (5 x 8 in).

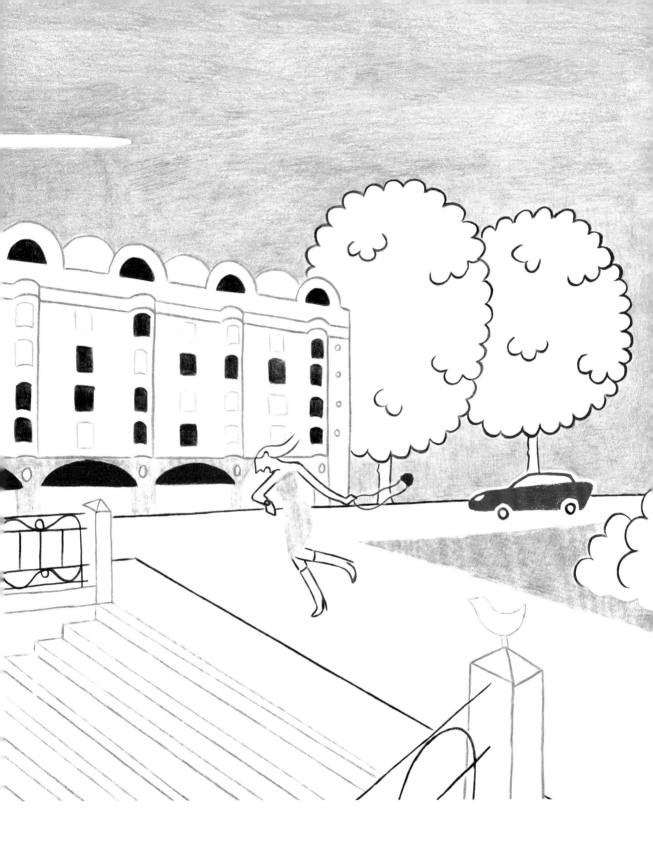

Zoran Pungerčar

Born: 1985, Postojna (Slovenia)
Lives: Ljubljana

Zoran Pungerčar's work crosses the borders of design, illustration and printmaking. He first became involved with design at secondary school through punk posters he did for a local music promoter, then he became interested in illustration and fine art towards the end of his degree in printmaking. When not drawing or painting, Pungerčar runs his own small press.

Artlessness I absolutely try to bring out my inner child in my work. I live close to the local kindergarten and there is a window through which you can see a mural that the children continuously draw and paint on. That is possibly my favourite kind of art.

Process I try to incorporate new materials in my practice all the time. Lately I've been experimenting with collages. I use a lot of different pencils and acrylics. When I work on commercial illustration projects for clients, I make my first sketches on paper before scanning them into my computer. However, I tend to steer clear of digital enhancement when it comes to my other works. My commercial projects are a lot more colourful; my personal work is predominantly black and grey. I can't think of any specific reason how and why this happens.

Working on a commercial illustration is usually a time-sensitive task. I begin by reading about a subject, then making preliminary sketches. I leave them aside, before picking the one I like most and basing my final piece on it. Painting is an entirely different process for me. I usually doodle in my sketchbook first, and the final result can look entirely unlike what I originally started out with.

Art versus illustration They are not necessarily opposed to each other, but I try to distinguish between them within my practice. Illustration is the act of describing something through images, and it also involves thinking about how to convey a certain message. There is also a difference in process: with illustration you're usually working with someone on the other side – an art director or client – and that changes the whole perception and feeling of creating the work. Art is somewhat more instinctive for me. I can feel drawn to something even if I can't explain why.

Far left:
Binoculars, 2012, digital, 71 x 50 cm (28 x 20 in).

Left:
Oka Toka 3, 2014, paper collage and acrylic on canvas, 70 x 50 cm (27½ x 20 in).

Opposite:
Chairs, 2012, digital, 71 x 50 cm (28 x 20 in).

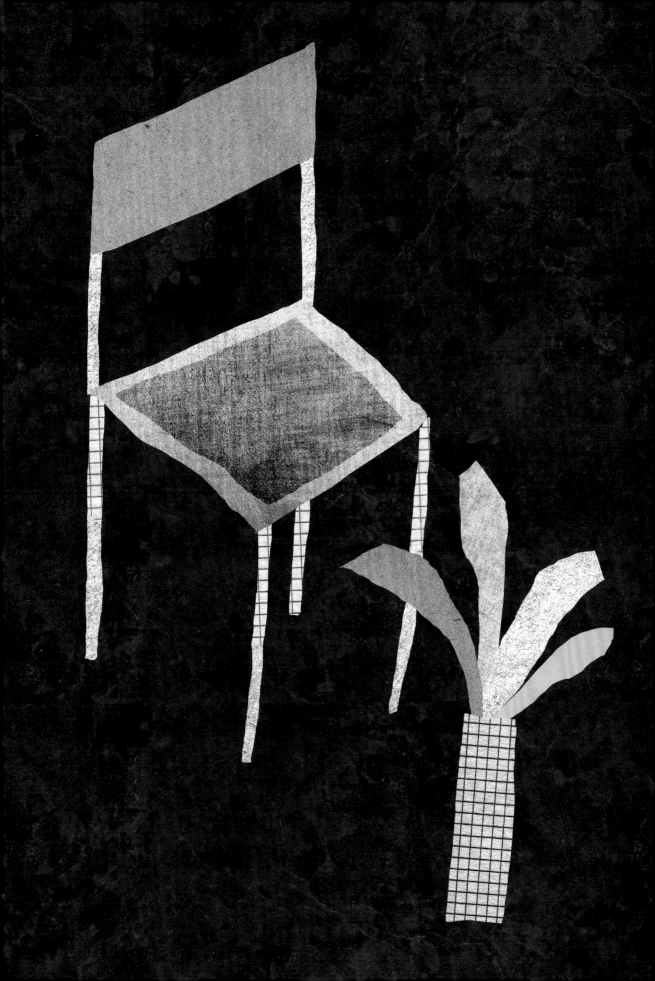

Above:
Oka Toka 7, 2014, acrylic,
ink and graphite on paper,
100 x 70 cm (39 x 27½ in).

Above:
Oka Toka 2, 2014, gouache
and graphite on paper,
100 x 70 cm (39 x 27½ in).

Opposite:
Nora Gregor, 2014, digital,
71 x 50 cm (28 x 20 in).

Brian Rea

Born: 1971, Woburn, Massachusetts
Lives: Los Angeles

Brian Rea started out with collages, but outgrew them after a few years because he felt they didn't embody his voice or personality at all. His current practice is a return to his early interest in storytelling, and he has also branched out into animation and film.

Background I studied at the Maryland Institute College of Art [MICA] in Baltimore. It was a wild place at the time, especially for someone who had grown up down the road from a cranberry bog. The library at MICA had these orange binders stuffed with old art and advertising annuals. It seemed like noone looked through this stuff, but to me it was all new and it had a huge impact on my work, especially the ink drawings of émigré artists with limited colour and unique compositions.

After tiring of collages, I realized that the work I was more excited about was in my sketchbook. I'd spend evenings drawing people and places in my Baltimore neighbourhood. It wasn't generating any money, but the exercise allowed me to focus on narrative and get back to the things I was most interested in without the pressure of deadlines or direction.

Later on, I moved to New York and shared a studio with the designer Paul Sahre. I live in Los Angeles now. I'm sure my mindset has changed. There is so much more space here in the west – better light, better weather, the room to make bigger work and the culture to experiment and support new directions. I've been here for almost six years and it still feels new. If I've been more productive while in the studio, I can go for a hike, or go for a surf once in a while. The emotions I experience from spending my leisure time then find their way back into my work.

Process I do no drawing on the computer, no vector line work. For now, the idea of drawing with a computer is like trying to win a giant stuffed animal at a carnival: everyone is telling me to try it, but I'll never win at that game.

I'll keep turning things over till I arrive at a few ideas that feel sharp, distinctly my voice, and visually graphic enough. I'll sometimes draw something over and over till I feel confident with the lines I've made – what they look like, and whether all of it together conveys the tone of the story I'm trying to tell.

Left:
FEARS, for the 'Murals' exhibition, Joan Miró Foundation (Barcelona, Spain), 2010, chalk and acrylic on wall, 5 x 9 m (16¹³/₃₂ x 29½ ft).

Opposite:
Attraction, 'Modern Love' column in *The New York Times*, 2015, graphite, ink and acrylic with digital, 36 x 25 cm (14 x 10 in).

West, poster for Rhode Island School of Design, 2015, graphite and ink on paper with digital, 82 x 60 cm (32 x 24 in).

Below:
Daughters depression, 'Modern Love' column
in *The New York Times*, 2015, graphite, ink and
acrylic with digital, 23 x 36 cm (9 x 14 in).

Bottom:
PAIN (A one year inventory), 2013.
graphite and ink on paper,
61 x 84 cm (24 x 33 in).

211

Rand Renfrow

Born: 1988, Midland, Texas
Lives: San Marcos, Texas

Squiggles, curious cactus-like plants and cartoonish characters populate Rand Renfrow's illustrations amid a riot of colour. The artist says that he doesn't know if he 'technically' went to art school. 'I went to a huge, public state university, but I did study art there.' Today he lives in a rural town in Texas and prefers it that way, being interested and involved in so many other things beyond art-making.

Background Personally I don't feel a connection between my current work and the idea of making art as a child. Part of what I'm trying to do when I draw is to use repetition and reduction and abstraction of common, everyday objects or scenes to develop my own sort of language and iconography that plays upon already established symbols in art. And then I'm interested in turning it over to the viewer to see what stories and interpretations different people have of the work. In that sense I don't think I'm trying to make anything unsettling. I am actually trying to attract the viewer, but I am definitely employing simplicity and reduction and rawness in a sense to do this, to get people to feel comfortable approaching the piece, instead of shying away thinking it is 'high art', or beyond their comprehension. Sometimes a drawing will be a little messier or rushed, but this is an attempt to add another layer of abstraction to the image through mark-making.

Process I usually use a pencil to draw something, or else I use screen-printing. More recently I've been messing around with acrylic paints. I don't exactly know what to say about screen-printing, honestly. It just makes sense to me. For some reason it's the easiest way of getting colour down for me to wrap my head around. If you do it long enough you eliminate the guesswork. There are also just so many tricks and ingenious ways of getting ink down via screen-printing, so I find it to be more versatile – and therefore more enjoyable – than painting or other ways of adding colour to a piece. Plus you get to produce multiples, which is something I definitely value as well. For most work I adhere to the philosophy that if someone really enjoys a piece of mine they should be able to get it and not be restricted by price or limited quantities. Screen-printing multiples definitely provides that opportunity.
 The key to my work these days really is constant sketching. I'm very attracted to the mundane and the everyday, so all the source material is simply from my daily life. I sometimes have a day job, preferably something with my hands, like construction or gardening or landscaping. I love going outside, travelling, hiking, swimming, camping, learning about plants, growing plants, meeting new people, reading non-stop, having interesting conversations, and of course occasionally perusing images I've bookmarked online or in books. And throughout all that I can't help but notice objects or how they interact with their environment and am either photographing them on my phone, which is perpetually running out of space, or drawing them – or an abstraction of them.

Opposite:
Postcard for CCOOLL, 2014, pencil
and digital colour, 10 x 15 cm
(4 x 6 in).

Above:
Illustration for Inner City Kidz shirt,
2013, pencil and digital colour.
38 x 30.5 cm (15 x 12 in).

Illustration for *Until Now* magazine,
2014, pencil and digital colour.
13 x 38 cm (5 x 15 in).

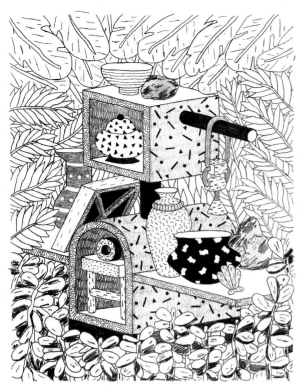

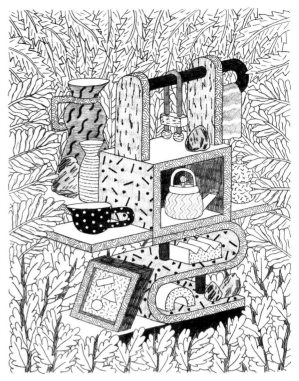

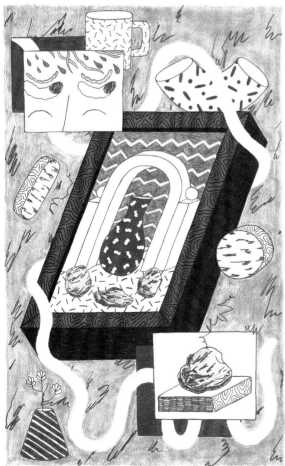

Top left:
Untitled, 2013, pencil, 28 x 23 cm
(11 x 9 in).

Top right:
Untitled, 2013, pencil, 28 x 23 cm
(11 x 9 in).

Bottom left:
Untitled, 2013, risograph print,
43 x 28 cm (17 x 11 in).

Bottom right:
Untitled, 2014, pencil and digital
colour, 28 x 21.5 cm (11 x 8½ in).

Illustrations for Bloomberg View,
2012. pencil and digital colour, each
1727 x 3000 pixels.

Emily Robertson

Born: 1983, Stockport (UK)
Lives: London

Emily Robertson's earliest memories of being fascinated by drawing involve poring over the sketchbooks her mother kept as a teenager. She would spend hours copying the images in these books, trying to understand how the lines on the paper came together to create a concrete entity. She explains that the way she draws has been a work in progress since she first picked up a drawing implement as a child: 'My style changes all the time, as it's something I do everyday and I never want it to get tired'.

Education I went to the Glasgow School of Art. Unlike London art schools, the class numbers were relatively small and we got to see our tutors most days. I guess that made for an open and honest environment – rather than feeling lost in a sea of faces. It opened me up to investigating the ideas and topics that I am interested in; it encouraged me to draw and not just to think, which I am still guilty of today; and it taught me how to structure projects. When I graduated and began showing my work to designers and agencies, I realized how free my education had been.

Technique I use watercolour almost exclusively now for all my final commissioned images. I started off working with inks, but I wasn't happy with how they felt when you put them on the paper – they dried too quickly, which made for a clunky finish. It was purely accidental that I bought some concentrated liquid watercolour (Dr. Ph. Martin's and Ecoline). I didn't even know such a thing existed. For me they are the perfect medium: the pigments are so vibrant and deep, and you can manipulate them once you have them on the paper to achieve a vast array of tones. I love the transparency and glow that results when you apply them on paper, too.

Process The whole ritual of making my drawings is so satisfying to me. I love laying out the colours in their glass bottles, choosing the brushes and mixing the colours. It makes me feel like an alchemist! The process of making maps is one of my favourites. The nerd in me really enjoys collating the information, figuring out what needs to be described, and what can be described in an interesting way.

Ideas Something I think about a lot is humanity's desire to make marks, to record and prove that they existed in time. Essentially, it boils down to the desire to be remembered. It's the reason why cavemen decorated caves with drawings describing their environment as well as for magical rituals. In the same way, my main inspiration comes from what I see around me.

Left:
Spot heads, from Robertson's sketchbook, 2011, watercolour and ink on paper, 15 x 21 cm (6 x 8 in).

Opposite:
Printed Pages editorial, from *Printed Pages*, 2013, watercolour on paper, 27 x 19 cm (11 x 7 in).

Minestrone

Mussels in white wine

(or beer)

PEELED PLUM TOMATOES

White Wine

OLIVE OIL

Fillets of ANCHOVIES

Tartare with tuna & anchovies & capers

Finnish Wild Mushroom Soup

Pea Soup

Dried Mushroom

Apartamento, from *Apartmento* magazine, 2010, watercolour on paper, 59 x 42 cm (23 x 16½ in).

Secret City, Los Angeles, Port
magazine 2013, watercolour on
paper, 29 x 23 cm (11½ x 9 in).

Sammy Stein

Born: 1979, Paris
Lives: Paris

Dabbling in animation, sound design and drawings in his student years at the École Nationale Supérieure des Beaux-Arts in Paris, Sammy Stein now describes himself as being 'totally addicted to the computer', although he occasionally still uses pens and watercolour in his work.

Going digital The computer is my co-pilot. Recently I made a book using a risograph printer and I felt very pleased with the colours and how the book came out. My girlfriend is a professional silk screen printer, so we often experiment with different techniques together.

Process I listen to a lot of music. Strange synthetic sounds like Oneohtrix Point Never inspire me a lot when I draw. I'm also interested in lyrics by underground French bands, the piano melodies of Ryuichi Sakamoto, and a lot of unknown bands. I make a lot of music compilations and I am able to listen to the same song ten times a day if I like it.

In my work, I try to mix fiction and reality. I am obsessed with certain questions. For example, when we go to the museum, I always wonder about the story behind each piece.

The other thing that really interests me is the notion of failure and defeat, especially the idea of a heroic character failing in a mission and dying at the end of a film or a song. Many of my drawings are inspired by these tropes.

Environment I belong to two collectives that I created with other artists. *Collection Revue* is a magazine about contemporary drawing that I have been contributing to since 2009. It's made up of interviews with artists, graphic novelists, outsider artists and graphic designers. It's very interesting to meet artists and speak with them about their art and other stuff as 'everyday life'.

The second one is a new publication called *Lagon* that I run with my friend Alexis Beauclair. Each issue has a different name and format. It is printed using risograph and silk screen, and showcases a selection of international artists. We are especially interested in experimental comics and the use of strange narratives in graphic novels.

Art versus illustration Illustration is order, art is open.

Left:
Randonnée 1, from the 'Randonnée' series, 2012, digital picture and silk screen, 50 x 65 cm (20 x 25½ in).

Opposite:
Untitled, extract from *Lagon* revue, 2014, digital picture and riso print, 19 x 13 cm (7½ x 5 in).

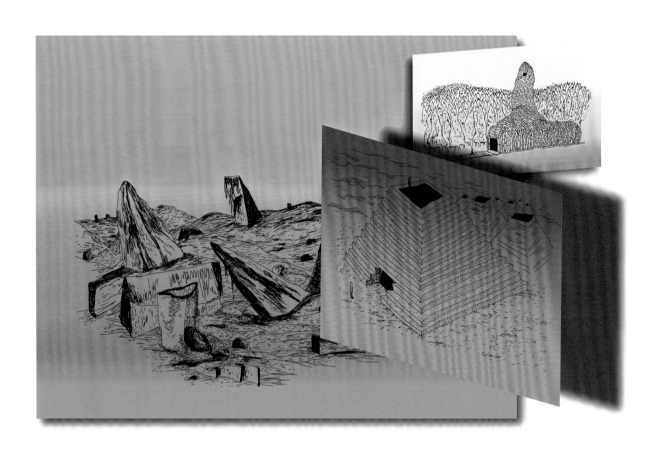

Various works from the 'Randonnée'
series, 2012, digital picture
and silk screen, 50 x 65 cm
(20 x 25½ in).

Fireworks, from the self-published
book *Fireworks*, 2014,
digital picture and riso print,
18 x 24 cm (7 x 9 in).

Zoë Taylor

Born: 1981, London
Lives: London

Zoë Taylor studied ancient history and archaeology, before realizing that she wanted to become an illustrator. She says of her background: 'I've got a lot of interests beyond drawing that have probably helped shape my approach – my love of cinema has been really influential.'

Evolution My parents both painted and drew, and they encouraged me to do the same when I was young. Back then I tried to draw accurately – it was all about shading and pencil rubbing. My approach now is far removed from what I did as a child, and relates more to my interests as a teenager. That's when I started to see culture in a different way. making links between the music, fashion, films and graphic art that I liked. I became more serious about image-making and started buying magazines like *i-D* and *The Face*, and I became more serious about image-making. I loved music and fashion spreads, and the way these media suggested atmospheric and open-ended narratives.

A sense of rawness and simplicity helps to create the effect I want – as though an image has just appeared and has nothing to do with my effort. But my work is also about conveying a feeling, and I like the way that rough drawings have that visual connection to thought. A thought can be very sudden and potent or it might be more tentative. Maybe this can be conveyed better in a sketch than in a very detailed drawing that's taken hours to produce.

Process I use traditional media such as pencil, ink, acrylic and felt-tip pen on paper. I only use digital tools for scanning and laying out zines. I like the physical feeling of using pencil on paperand the textured effect adds to the atmosphere of the drawing.

I sometimes draw directly from imagination, but my best work is often improvised with some kind of found image reference – I've got folders full of stills I've taken from films, and images I've found online or in books. Commissions are different. I often get ideas quickly, but making lots of rough sketches takes time. I'll come up with a number of alternate versions because the final drawing should work on the page but still look fresh. If I'm doing something sequential, like a comic, it's very carefully planned.

I love films by Robert Aldrich, Rainer Werner Fassbinder and Dario Argento. I like the heightened feeling in these works – they're very melodramatic and they take you into a strange other world that has you on edge. I'm also influenced by film stills. The heightened drama is there, but not the context, which gives them a haunting and mysterious quality. I'm interested in grey areas and the way the mind tries to find meaning and make connections between things, but I'm also fascinated by feeling, surfaces and glamour. Ultimately, I want to create images or stories that convey a certain kind of atmosphere.

Left:
Hyperfeminine Pastels, Louis Vuitton SS12 for *AnOther*, 2012, pencil on paper, 21 x 25 cm (8 x 2 in).

Opposite:
Bored, from 'The Girl Who Fell to Earth', 2012, ink on paper, 42 x 30 cm (16½ x 12 in).

Top:
Saturn, from 'The Girl
Who Fell to Earth',
2014, ink on
paper, 30 x 42 cm
(12 x 16½ in).

Middle:
Untitled, from
'The Girl Who Fell to
Earth', 2014, ink on
paper, 30 x 42 cm
(12 x 16½ in).

Bottom:
Floating, from
'The Girl Who Fell to
Earth', 2014, ink on
paper, 30 x 42 cm
(12 x 16½ in).

Gasp, 2009, pencil on paper,
42 x 30 cm (16½ x 12 in).

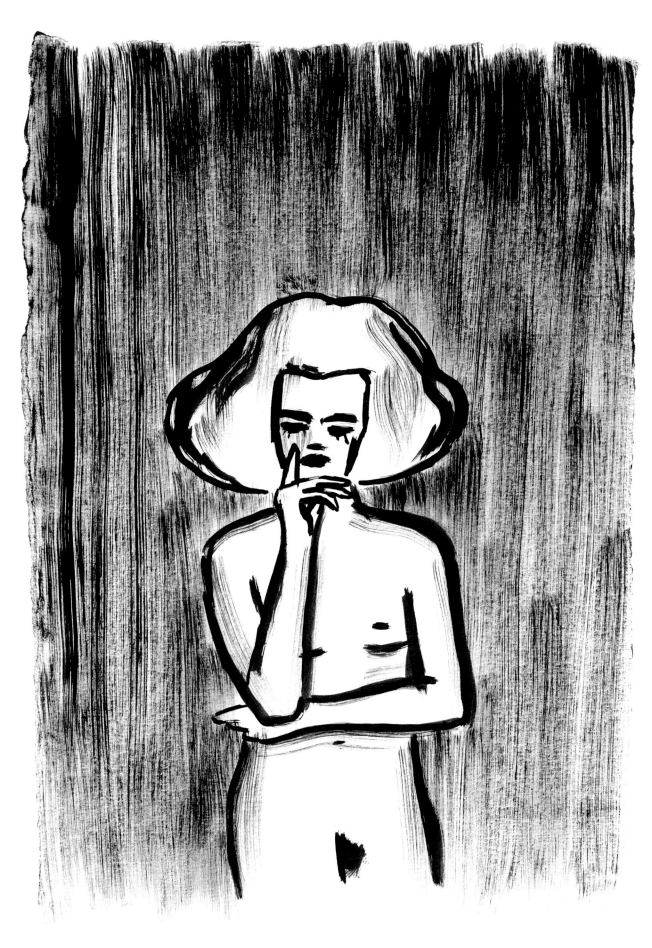

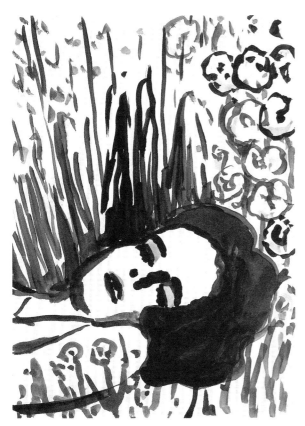

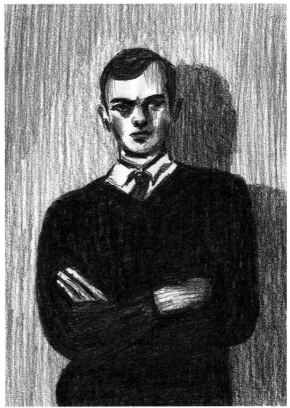

Opposite:
Untitled, from 'The Girl Who Fell to Earth', 2014, ink on paper, 42 x 30 cm (16½ x 12 in).

Above left:
Flowers, 2009, ink and acrylic on paper, 21 x 15 cm (8 x 6 in).

Above right:
Cy, 2010, pencil on paper, 21 x 15cm (8 x 6 in).

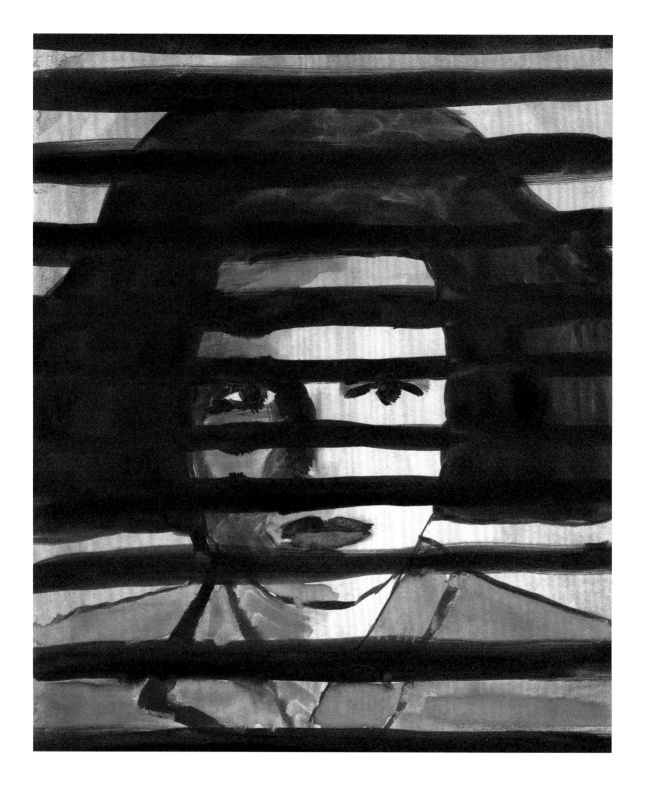

Untitled, 2009, ink on true grain,
30 x 21 cm (12 x 8 in).

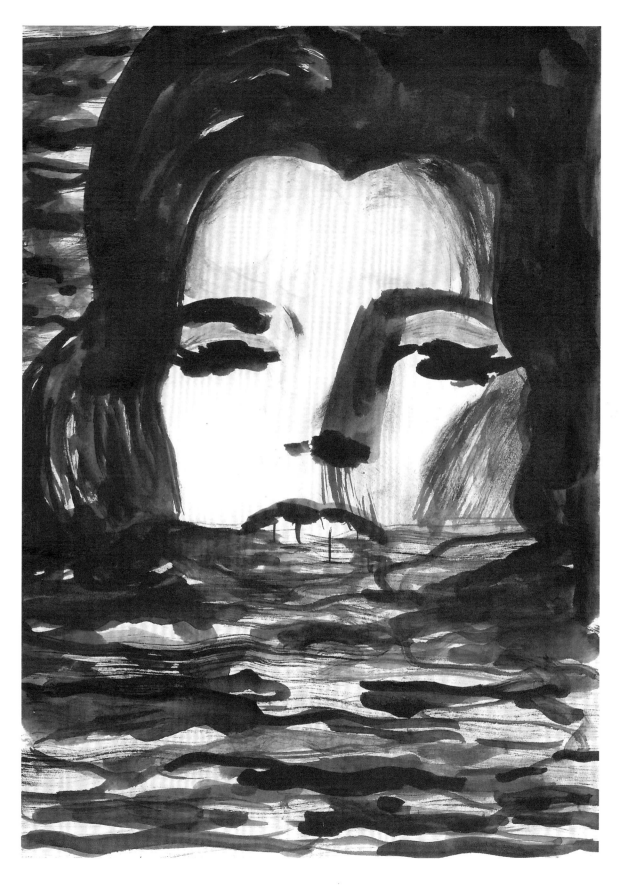

Swimmer, 2009, ink and acrylic
on paper, 21 x 15 cm (8 x 6 in).

Simon Thompson

Born: 1988, Paris
Lives: Paris

As a child, Simon Thompson drew inspiration from Japanese, American and French animated series to create images of his own fantasy world. Having experimented with many different styles and phases, Thompson says that his practice remains in evolution.

Education I entered the [École Nationale Supérieure des] Arts Décoratifs in Strasbourg in 2007. It's a great art school located in eastern France, close to the German border. I spent six years there and graduated in illustration in 2012. I learned screen-printing, having been blessed with (maybe) the best screen-printing workshop you could find in an art school.

Artlessness Some children grow up wanting to become an artist, or at least knowing that they want to keep creating stuff when they grow up. They just KNOW! I wasn't one of those. I just liked to draw from time to time. That said, my childhood inspirations have been, and still are, a big part of my work. Unsettling the viewer is a goal I try to achieve continuously. I create simple situations that can tell a thousand stories.

Process I always start on paper. I often use felt-tip pen for the outlines and black coloured pencils for the shading. Then I scan the whole thing into the computer and put in the colours using Photoshop. The software helps me create different layers for the screen-printing process.

 I print all my work using screen-printing, so I guess it's a pretty exclusive relationship. Screen-printing is a big part of my life and, working in a workshop every day, I'm surrounded by more craftsmen than artists. I have less time to continue my personal work, but I'm working on finding a better balance between my two passions.

 I rarely create an original. I draw all the components of an image separately on basic plain white printing paper. If a component isn't good enough, it goes in the bin. Once I have scanned all the components, I have no interest in keeping them. I sometimes keep them for a while, but I only care about the final screen-printed image.

Opposite:
Untitled, from 'Welcome to trichomie', 2012, three-colour screen print, 70 x 100 cm (27½ x 39 in).

Above:
Paramiamor, 2013, eight-colour screen print, 38 x 28 cm (15 x 11 in)

Overleaf:
Untitled, from 'Welcome to trichomie', 2012, three-colour screen print, 70 x 100 cm (27½ x 39 in).

Above:
From *Prétexte à dessiner
des femmes nues*, 2012,
CMYK screen-printed book.

Top:
Crazy Universe 3, 2013,
five-colour screen print,
38 x 56 cm (15 x 22 in).

Above:
Crazy Universe 1, 2013,
five-colour screen print,
38 x 56 cm (15 x 22 in).

Charlotte Trounce

Born: 1988, Tunbridge Wells (UK)
Lives: London

Charlotte Trounce believes that she entered the illustration industry at a time when people 'were starting to appreciate "handmade" again'. In order to find her style, she pared down everything she had been taught into its simplest form.

Materials I mostly use acrylics. But I enjoy the process of mark-making: using different tools and materials (crayons, inks and pastels) to create textures, which I then add to my designs. I use a computer to arrange the illustrations, taking all the individual elements I have created by hand and working them into a composition I am happy with. As a commercial illustrator working on commissions for clients, it is important to be able to make changes to the work easily and quickly, and working part-digitally allows me to do this. Although over time I have come to use the computer more often, I do want to continue always making work by hand – I think that's what will make my illustrations stand out.

Although I've been working with acrylics for many years now, I've recently enjoyed experimenting with the paint a lot more, applying it thickly with a dry brush, or watering it down and allowing the colours to flow into one another. I like to find new ways to use the medium, seeing how far I can push it.

Process I start each new piece of work by working in my sketchbook, jotting down any ideas that come to me, having read through the brief. I generally find that my best ideas are those that come to me quickly. Once I'm confident about the idea and the rough design (and the client is too!), I start working on the final artwork. Although my process is fairly consistent, I don't usually have a completely clear plan as to how the finished design will look – I will decide, for instance, on a colour palette as I go.

Opposite:
Marni SS15, 2015, acrylic on paper,
13 x 18 cm (5 x 7 in).

Above:
Counting chart for The Garden Centre Group,
2014, acrylic and crayon on paper,
119 x 84cm (47 x 31 in).

Opposite:
Future Library, for *Riposte*
magazine, 2015, acrylic on paper,
30 x 21 cm (12 x 8 in).

Above left:
Foliage, wrapping paper for
Wrap magazine, 2014, acrylic on
paper, 70 x 50 cm (27½ x 20 in).

Above right:
Celine SS15, 2015, acrylic on paper,
18 x 13 cm (7½ x 5 in).

3,95€

THE
PARISIANER

27 Novembre 2013

The Parisianer, 2013, acrylic and crayon on paper, 42 x 32 cm (16½ x 12½ in).

Fiera Magazine no. 2, 2015,
acrylic and crayon on paper,
22.5 cm x 17 cm (9 x 6½ in).

Alice Tye

Born: 1991, Kent (UK)
Lives: London

Choosing to work only with oils, Alice Tye contrasts vibrant hues with rich, dark tones. She used to use only pencil, and explains that switching to painting has completely changed the atmosphere that she is able to communicate in her work.

Education I went to Camberwell College of Arts [part of the University of the Arts London] for both my foundation diploma and my bachelor's degree in illustration. There I learned that illustration could be applied to anything: television set design, gallery-based work, 3D work.

Materials I work almost entirely in oil or acrylic on paper, painting in quite a traditional way. Having said that, though, I often make my initial compositions by creating rough photo-collages using Photoshop, from which I then paint. More recently, I've been working on layering paint to create more depth, and allowing the brushstrokes to show in certain areas of a piece, creating textures that contrast with smooth, flat areas of colour.

I have noticed that I often use a lot of blue in my paintings. I'm quite drawn to clear blue skies and water, so I think I subconsciously include these in a lot of my work.

Inspiration In my last year at university I began to connect my interest in cinema with my illustration work, and that has continued to be a key source of inspiration. I'm interested in how a film can convey a narrative and a sense of atmosphere. I'm also incredibly drawn to California, or at least my perception of it as portrayed in pop culture, and that is a recurring theme in my work. I will be visiting it later this year, making pilgrimage-like visits to all the places I have painted, such as La Jolla Road in Palm Springs, which I painted in 2013 using images taken from Google Street View. I then plan to make a new series of works based on the realities of these locations, in contrast to my earlier pop culture-inspired paintings.

Below:
LA Confidential, 2013, oil on paper, 29 x 59 cm (11 x 23 in).

Opposite:
Drive to Thriftimart, 2014, oil on paper, 30 x 21 cm (12 x 8 in).

Opposite:
Motel II, 2014, oil on paper,
30 x 21 cm (12 x 8 in).

Above:
Miami Vice, 2014, oil on paper,
30 x 42 cm (12 x 16½ in).

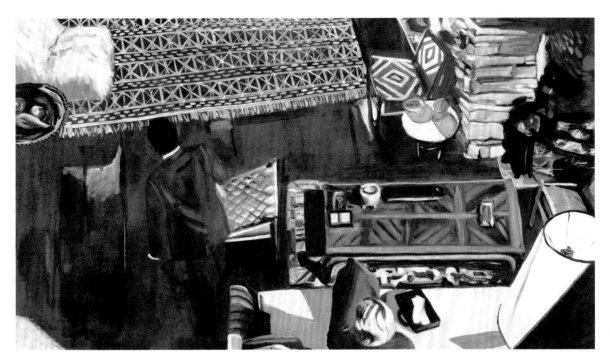

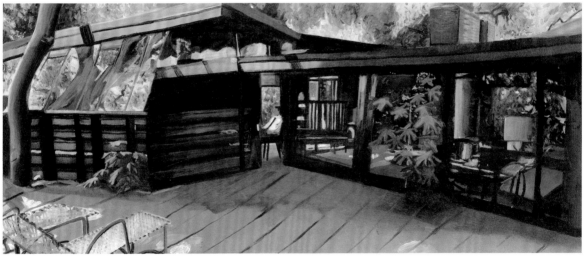

Opposite:
Freeway I, 2014, oil on paper,
30 x 21 cm (12 x 8 in).

Top:
North By Northwest, 2013, oil on
paper, 32 x 60 cm (12½ x 24 in).

Above:
A Single Man, 2013, oil on paper,
25 x 60 cm (10 x 24 in).

Emi Ueoka

Born: 1981, Tokyo
Lives: Melbourne

The Japanese-born illustrator Emi Ueoka attended secondary school and university in England. She says of the places she has lived in: 'Being in Melbourne has definitely created more time for me to get in touch with myself. I also happen to live close to a nature trail and I see a lot of beautiful things along my walk, so I tend to draw a lot of my surroundings nowadays. In comparison, when I was in Japan, I used to draw my fantasy world a lot more.'

Background I've always enjoyed drawing, but I only pursued it seriously when I started living in Australia about four years ago. I was working as an editorial designer in Tokyo before that. My personal style has developed with practice.

I went to Central Saint Martins College [in London] and spent most of my time in the school library, taking photocopies of old font books, or at antiques and vintage markets, trying to spot charming old details on clothing or household objects that I could then visually record in my scrapbook.

Materials I use lead pencils and coloured pencils. I like their casualness, as I can just start drawing without any preparation, and my mistakes can be easily fixed by using an eraser. I have no problem using the computer, but it's never a big part of my creative process. I have developed a love/hate relationship with shading. I like the outcome but my right arm often gets sore from it. So I don't do it as often as I'd like.

Process I usually draw from memory or imagination. As I move on to other rounds of sketches, I eliminate unnecessary lines to find the amount of detail I like. I try not to over-plan my drawings because they never end up looking good when I spend too much time on them. I'm often drawn to little roadside flowers or girls walking who seem to be not yet aware of themselves. I also draw a lot of schoolgirls, as I like seeing the repetitive lines and shapes of their pleated skirts and their hairstyles.

Below:
Boy & Girl III, for 1LDK, 2015, pencil on paper, 29 x 42 cm (11½ x 16½ in).

Opposite:
Iris, for Nieves Books, 2015, pencil on paper, 20 x 14 cm (8 x 5½).

Opposite:
A Schoolgirl with her Sketchbook,
2013, pencil on paper, 42 x 29 cm
(16½ x 11½ in).

Above left:
A Schoolgirl in Japan, 2013, pencil
on paper, 29 x 21 cm (11½ x 8 in).

Above right:
Three Girls, 2013, pencil on paper,
42 x 29 cm (16½ x 11½ in).

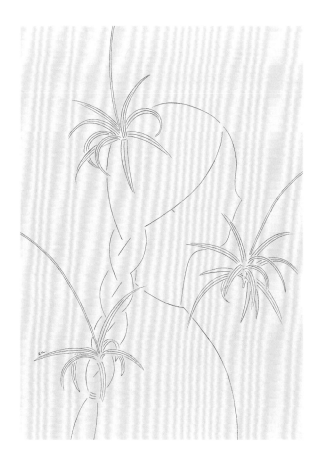

Opposite:
Boy & Girl, for 1LDK, 2015, pencil on paper, 42 x 29 cm (16½ x 11½ in).

Above left:
Spider Plant, for The Plant, 2014, pencil on paper, 29 x 21 cm (11½ x 8 in).

Above right:
Little Flowers, 2014, pencil on paper, 29 x 21 cm (11½ x 8 in).

Clément Vuillier

Born: 1989, Bagnères de Bigorre (France)
Lives: Saint-Maurice (France)

Clément Vuillier learned drawing from his father, who was an art teacher. It was a combination of his father's influence with Vuillier's own love for old scientific images and landscape paintings that shaped the direction of his practice.

Background I attended two art schools. After my Bachelor of Applied Arts, I spent two years at the École Estienne in Paris, where I undertook my second degree in illustration. Then I moved to Strasbourg to continue pursuing my interest in illustration. There I met many people who later became my frequent collaborators, and I picked up publishing, binding and silk screen techniques. This allowed me to establish the publishing house 3 fois par jour with [the illustrator] Idir Davaine.

Process I'm more naturally focused on the really graphic techniques such as graphite, pen and ink. I try to use the computer as little as possible. It often comes after the work of pure drawing and image processing. Spending days in front of a screen isn't my cup of tea at all.

I'm not always happy with what I produce, but that suits me fine since I'm more interested in the failures and the meanderings anyway. I make myself draw a certain number of pictures per day, and try to stick to this system. This helps to harmonize the images, and means that I don't spend too much time on each.

Below:
Bleau, 2014, Indian ink on paper,
48 x 65 cm (19 x 25½ in).

Opposite:
Bogue, 2014, Indian ink on paper,
48 x 32 cm (19 x 12½ in).

Opposite:
Dirigeables, 2014, silk screen on
paper, 70 x 50 cm (28 x 20 in).

Above:
feu 6, 2015, Indian ink on paper,
40 x 28.5 cm (16 x 11 in).

Philippe Weisbecker

Born: 1942, Dakar (Senegal)
Lives: Paris

'When I go to a new town, I don't go to the art museum, I go to the hardware store', Philippe Weisbecker tells us. He spent the last quarter of the twentieth century in the United States, where he regularly drew covers for *The New Yorker* and contributed to *The New York Times* op-ed page. But he mostly works on self-initiated projects these days, drawing increasingly simple objects. They invite him to envisage 'a universe of ever more refined minimalism, a universe where the line is itself an object'.

Process I like to destroy perspective because I like to flatten things. I use paper, which is flat, so I think drawing things flat is better. Every time I start on a new drawing, I can't help but flatten the selected object on its support. I like the way that the object thus passes from three to two dimensions, the dimensions of the support. The object no longer has any protruding angles or sides to allow my mind to apprehend or examine it.
In the space between its carapace, which offers itself to the viewer, and its support, from which it is now indissociable, resides all its mystery.

Style My early illustration work really caught on – but not in the way I was hoping. I had the feeling that giving clients their money's worth meant putting a great amount of physical effort into a drawing. It was a guilty feeling that held sway over me for many years. I was aware of style, but I wanted my style to disappear behind the image. Mine was ultimately an intellectual pursuit. The best of me wasn't to come out until much later, when I could draw unself-consciously without being tied to the idea.
[When I was 40] I decided to draw what was around me and, more important, I decided that everything I did was going to fit on one single sheet of paper, regardless of size – therefore I wouldn't have any sense of proportion or scale in the drawing. I just wanted to record whatever there was in my vision area, in any way possible. I was amazed that the objects I drew didn't have to conform exactly to reality as long as they could somehow be identified. That's when I realized what drawing is for me. It's not reproducing what I see, but what I can record. And whatever the manner – realistic or abstract – doesn't matter, because it's merely an image. Nobody sees what I see anyway, they just see the image I make.
My whole life has been made up of new starts. Philip Guston only really discovered himself at the age of 60. Hokusai did his best work between the ages of 70 and 80. The opportunity for me hasn't passed, then. What good fortune!

France versus America versus Japan In France, they worry about influences. In America, they don't. There, if you can use it, fine. In Japan they don't distinguish between art and applied art, which is wonderful.

Left:
Ecodeco Samantha, from the 'ECODECO SOPHA' series, 2007, graphite and coloured pencil on paper, 30 x 38 cm (12 x 15 in).

Opposite:
From the 'MIRROR' series, 2007, silver powder, graphite and shoe polish on paper, 35 x 28 cm (14 x 11 in).

MAIN STREET NIKKO 2009 4

Main Street Nikko 2009 # 4, from the 'MAIN STREET NIKKO' series, 2009, graphite and coloured pencil on paper, 24 x 30 cm (10 x 12 in).

Main Street Nikko 2009 # 9, from
the 'MAIN STREET NIKKO' series,
2009, graphite and coloured pencil
on paper. 24 x 30 cm (10 x 12 in).

Top left:
Meitetsu, from the 'KYOTO AXI'
series, 2002, graphite and coloured
pencil on paper, 23 x 34 cm
(9 x 13½ in).

Top right:
Geminy, from the 'TRAILER' series,
c.2003, graphite and coloured
pencil on paper, 31 x 42 cm
(12 x 16½ in).

Above left:
Cabin Cruiser, from the 'TRAILER'
series, c.2003, graphite and
coloured pencil on paper,
31 x 42 cm (12 x 16½ in).

Above right:
Alite, from the 'TRAILER' series,
c.2003, graphite and coloured
pencil on paper, 31 x 42 cm
(12 x 16½ in).

Opposite:
From the 'RED' series, 2014, gouache
and coloured pencil on paper, each
32 x 45 cm (12½ x 18 in).

Overleaf:
From the 'BRUSHES' series, 2011,
sepia pencil on paper, 42 x 51 cm
(16½ x 20 in).

Picture Credits

The authors and publisher would like to thank the following companies and individuals for permission to reproduce images in this book. In all cases, every effort has been made to credit the copyright holders, but should there be any omissions or errors the publisher would be pleased to insert the appropriate acknowledgement in any subsequent edition of this book.

T = top; B = bottom; L = left; R = right

Ianna Andréadis
All images, courtesy of the artist.

Edouard Baribeaud
All images, courtesy of the artist.

Tiziana Jill Beck
All images, courtesy of the artist.

Virginie Bergeret
All images, courtesy of the artist.

Serge Bloch
All images, courtesy of the artist.
28L, 28R, 29, 30, 31, 32 and 33 photography by Serge Bloch.
34–35 photography by Myrzick & Jarish for the *Süddeutsche Zeitung* magazine.

Laura Carlin
All images, courtesy of the artist.
37 produced for *The New York Times*, courtesy of Laura Carlin and Heart Agency.
38–39 produced for *The Promise* written by Nicola Davies, courtesy of Laura Carlin and Walker Books.
41 produced for *Le Grand Meaulnes* written by Alain Fournier, published by The Folio Society, courtesy of Laura Carlin and Heart Agency.

Édith Carron
All images, courtesy of the artist.

Sofia Clausse
All images, courtesy of the artist.

Damien Florébert Cuypers
All images, courtesy of the artist.

Paul Davis
All images, courtesy of the artist.

Jean-Philippe Delhomme
All images, courtesy of the artist.

Marion Deuchars
All images, courtesy of the artist.
70L courtesy of David Hieatt/Do Lectures.
68, 69 and 70R courtesy of Laurence King Publishing.

Nathalie Du Pasquier
All images, courtesy of the artist.

Juliette Etrivert
All images, courtesy of the artist.

Daniel Frost
All images, courtesy of the artist.

Si-Ying Fung
All images, courtesy of the artist.

Louis Granet
All images, courtesy of the artist.

Sofie Grevelius
All images, courtesy of the artist.

Kim Hiorthøy
All images, courtesy of the artist.
102 courtesy of STANDARD (OSLO).

Masanao Hirayama
All images, courtesy of the artist.

Kyu Hwang
All images, courtesy of the artist.

Marie Jacotey
All images, courtesy of the artist.

Faye Coral Johnson
All images, courtesy of the artist.

Misaki Kawai
129 and 133 courtesy of Misaki Kawai and The Hole, NYC.
130, 132TL and 132BR courtesy of Misaki Kawai and Take Ninagawa, Tokyo.
131TL courtesy of Misaki Kawai and Cheim & Read, NYC.
131TR courtesy of Misaki Kawai and Eric Firestone Gallery, NY.
131BL courtesy of the Misaki Kawai and Katherine Bernhardt.
131BR courtesy of Misaki Kawai.
132TR courtesy of Misaki Kawai and Loyal, Sweden.
132BL courtesy of Misaki Kawai and KAWS.

Anna Kövecses
All images, courtesy of the artist.

Patrick Kyle
All images, © Patrick Kyle.

Simon Landrein
All images, courtesy of the artist.

Miju Lee
All images, courtesy of the artist.

Maria Luque
All images, courtesy of the artist.

Clara Markman
All images, courtesy of the artist.

Vania Mignone
All images, courtesy of the artist and Casa Triângulo.
169TR and 169BR photography © Everton Ballardin.
166, 167, 168T, 168B, 169TL, 169BL, 170TL, 170TR, 170BL, 170BR and 171 photography © Edouard Fraipont.

Virginie Morgand
All images, courtesy of the artist.
172R poster for the 2014 Festival de Martigues courtesy of Virginie Morgand and the Festival de Martigues directors. Graphics courtesy of Pauline Leynand.

Robert Nicol
All images, courtesy of the artist.

Malin Gabriella Nordin
All images, courtesy of the artist.
184 photography by Erik Wåhlström.

Marcus Oakley
All images, courtesy of the artist.

Adrien Parlange
All images, courtesy of the artist.
190–193 commissioned by Vandejong Creative Agency. Courtesy of Adrien Parlange and Vandejong Creative Agency.

Jeremy Piningre
© Jeremy Piningre, Piningre Studio.

Federica Del Proposto
All images, courtesy of the artist.

Zoran Pungerčar
All images, courtesy of the artist.

Brian Rea
All images, courtesy of the artist.
208 Curator: Martina MIlla.
209 Art Director: Barbara Richer.
210 Designer: Robert Brinkerhoff.
211T Art Director: Barbara Richer.

Rand Renfrew
All images, courtesy of the artist.

Emily Robertson
All images, courtesy of the artist.
221 creative direction from Kuchar Swara.

Sammy Stein
All images, courtesy of the artist.

Zoë Taylor
All images, courtesy of the artist.

Simon Thompson
All images, courtesy of the artist.

Charlotte Trounce
All images, courtesy of the artist.
241 commissioned by Kiwi & Pom for The Garden Centre Group.
242 courtesy of Charlotte Trounce and Danielle Pender (Editor), *Riposte* magazine.
243 Art direction by *Wrap* magazine.
244 © *The Parisianer* and Charlotte Trounce. Art direction by Aurélie Pollet and Michael Prigent.
245 Courtesy of *Fiera* magazine.

Alice Tye
All images, courtesy of the artist.

Emi Ueoka
All images, courtesy of the artist.

Clement Vuillier
All images, courtesy of the artist.
260 published by Éditions 3 FOIS PAR JOUR, www.3foisparjour.com. Courtesy of Clément Vuillier and Éditions 3 FOIS PAR JOUR.

Philippe Weisbecker
All images, courtesy of the artist.

Marc Valli is the founder of the retail and book-selling company Magma as well as the magazines *Graphic* and *Elephant*. His books include *RGB: Reviewing Graphics in Britain*, *Walk the Line*, *Microworlds* and *A Brush with the Real: Figurative Painting Today*.

Amandas Ong is a social anthropologist and occasional writer. She was previously web editor of the visual arts quarterly *Elephant*.

Published in 2016 by
Laurence King Publishing Ltd
361–373 City Road
London EC1V 1LR
United Kingdom
email: enquiries@laurenceking.com
www.laurenceking.com

A catalogue record for this book is available from the British Library

ISBN: 9781780678535

Design: Roger Fawcett-Tang/Struktur Design Limited

Printed in: China

Front cover: Vânia Mignone, *Untitled*, 2013. Courtesy of the artist and Casa Triângulo, photography © Edouard Fraipont.

Back cover: Ianna Andréadis, *Cactus*, from the book *Cactus*, published by Petra Ediciones, 2005. Courtesy of the artist. (The reproduction of the drawing is inverted.)